THE
INVISIBLE
DRAGON

DAVE HICKEY

THE UNIVERSITY OF CHICAGO PRESS · CHICAGO AND LONDON

THE INVISIBLE DRAGON

~ESSAYS ON BEAUTY

REVISED AND EXPANDED

Dave Hickey is professor of English at the University of Nevada–Las Vegas. A former executive editor of *Art in America,* he has also served as a contributing editor for the *Village Voice* and as the arts editor of the *Fort Worth Star-Telegram.*

The University of Chicago Press, Chicago 60637
The University of Chicago Press, Ltd., London
Revised and expanded edition © 2009 by The University of Chicago
Original edition © 1993 The Foundation for Advanced Critical Studies
Text © 2009, 1993 Dave Hickey
All rights reserved. Published 2009
Printed in the United States of America

18 17 16 15 14 13 12 11 10 09 2 3 4 5

ISBN-13: 978-0-226-33318-2 (cloth)
ISBN-10: 0-226-33318-3 (cloth)

The Invisible Dragon was originally published by Art Issues Press in 1993. For permission to reprint, please contact the Permissions Office, The University of Chicago Press, 1427 East 60th Street, Chicago, IL 60637.

♾ The paper used in this publication meets the minimum requirements of the American National Standard for Information Sciences—Permanence of Paper for Printed Library Materials, ANSI Z39.48-1992.

Library of Congress Cataloging-in-Publication Data
Hickey, Dave, 1940–
 The invisible dragon : essays on beauty, revised and expanded / Dave Hickey.
 p. cm.
 ISBN-13: 978-0-226-33318-2 (cloth : alk. paper)
 ISBN-10: 0-226-33318-3 (cloth : alk. paper)
 1. Aesthetics. 2. Art—Philosophy. I. Title.
N70.H47 2009
701'.17—dc22
 2008041463

This edition of *The Invisible Dragon* is for

Glenn Schaeffer

Connoisseur, littérateur—an invisible dragon himself

L'aimable siècle où l'homme dit à l'homme,

Soyons frères, ou je t'assomme!

Guillaume Pigault-Lebrun (1753–1835)

SCOTT GRIEGER *Squares Masquerading as Artists*

ACRYLIC ON PANEL, 1997.
COURTESY OF THE ARTIST AND THE
JUDY VIDA AND STUART SPENCE
COLLECTION.

CONTENTS

Dragon Days: Introduction to the New Edition

We grow rusty and you catch us at the very point of decadence—by this time tomorrow we might have forgotten everything we ever knew.

Tom Stoppard, *Rosencrantz and Guildenstern Are Dead*, act 1

First, understand this. The four essays that open this book are not characteristic of his writing. They are perfectly sincere, and he still believes everything he wrote in these essays. He just can't believe he wrote them. He imagines himself a teddy bear, the master of the sleepy wave. Usually, when he writes, he keeps a relaxed hand on the rein, the better to veer out of control at the slightest provocation. The four essays that open this book—written in response to great provocation—never veer. Tendrils of black smoke curl from between the words. Whiffs of bad juju rise from the pages. Their ambience of hallucinated intensity and icy aggression is, perhaps, not that forgiving of everyday human fecklessness. For this reason, he took *The Invisible Dragon* out of print many years ago, and he only offers the four initial essays now, somewhat polished, in tandem with a fifth, "American Beauty," that is calmer, more capacious, and less scolding in its tone. This essay veers where

it wishes to infer a history for the West's long, pagan romance with beautiful things.

The actual occasion for his writing anything about beauty was the plague of intellectual dishonesty that infected every aspect of the controversy surrounding the public exhibition of Robert Mapplethorpe's beautiful, pornographic photographs. Everybody involved in this cringe-inducing scandal lied like bandits and cloaked themselves in bright mantles of hypocrisy. Everyone had a dog in the fight. Everyone had money on the line. The critic only joined the fray because Robert Mapplethorpe had been a pal of his in the old downtown days. Being dead, Robert couldn't speak for himself. Being idiots, his defenders couldn't even defend themselves, so the critic stepped in on his friend's behalf—mostly just to acknowledge him in all his unreconstructed wickedness.

Appalled at the congeries of whiners, he wrote "Enter the Dragon" to clear the air of cant. He couldn't do it. He wrote "Nothing like the Son" for a magazine in Zurich because no one had written a serious piece of art criticism about Mapplethorpe's *X Portfolio*. The magazine declined to publish the essay with the images he submitted. He resorted to the lecture hall. He wrote "Prom Night in Flatland" for a feminist magazine in Cologne because he is a feminist. "After the Great Tsunami" was written as homage to Gilles Deleuze, who was under the weather at the time. All of these essays occasioned anger and exasperation. Tempers flared. Things turned nasty at the inter-

section of art and politics. He tried to function throughout as he always has, as an art critic.

Even so, long before *The Invisible Dragon* was a book, he faced the real possibility of being shot by both sides in the culture war. His writing aroused genuine personal rancor, and this was distressing because he is not a personal person. He is, in fact, a third-person person who writes art criticism because it is third-person writing. Now people actually *hated* him (the word "loathsome" was bandied about). The sudden attention was as shocking as the hostility. He had been purveying unfashionable opinions for twenty years, relying on charm and equanimity. Now, even good-heartedness was failing him. People were trying to shout him down, and he was tempted to let them. What did he care?

Hitherto, his transit through the beaux-arts milieu had been virtually clandestine. He was there for the art. He appeared, when he appeared, in print. He talked with his fellow critics on the telephone. He had lunch with artists—but never dinner, except at galas and dinner parties. Occasionally, he sought the counsel of art dealers like Leo Castelli, whom he knew and respected from his own days as a New York art dealer in the sixties. Otherwise, he kept to himself, and, before *l'affaire Mapplethorpe*, things were fine. He lived at the beach, five hours south of Los Angeles, light-years from the snowbound fortresses of the burgeoning theory industry. He held himself apart from art world entanglements lest he

be tempted to hold his tongue out of friendship or obligation. He wrote essays in the modest tradition of Hazlitt, Lamb, De Quincey, and Wilde about the way art objects looked.

The hostile response to the essays that would become *The Invisible Dragon*, however, made him anxious about his ability to secure employment. Since he never worried about anything, really, except living in cool places, this anxiety made him feel like an aging sissy. And feeling like an aging sissy reignited the rock-and-roll spark in his rebel heart. If he was going down, he resolved, he was going down spunky, guns blazing. So he got youthful and wrote *The Invisible Dragon* for the same reason he had written so many snotty rock-and-roll songs when his hair was long. Even so, he never imagined that a slim volume, published in the Hollywood Hills, out of Gary Kornblau's extra bedroom, had the slightest chance of making a dent. Nor did he care. He thought of *The Invisible Dragon* as an "oldies concert," played for the sheer joy of cranking up the amps one more time.

Today, he likes to think that the spit and clatter of the Rolling Stones' "Respectable" provides a pretty accurate aural equivalent to *The Invisible Dragon*, and, as a rock-and-roll song, the *Dragon* was a successful book. It appealed to children and other adepts of ecstasy. He signed and dedicated books to "Chantoozie," "Rip Nu 1," and "Burp Daddio," among others. In the *Dragon's* wake, he gave lectures in university auditoriums during which the faculty rose

en masse from their seats in the back row and marched out. Honorariums were withheld. Dinners were canceled. Litigation was threatened. The endowed lecturer was deposited unceremoniously at a Ramada Inn beside an empty highway and left to dine out of the candy machine. The endowed lecturer found this hurtful, but less and less so as time went on. He sat on the bed in his motel room. He contemplated the blond furniture. He stared out into the black midwestern night. Tiny lights twinkled in the distance. If he were still in a band, he could have been sitting at a Denny's drinking coffee with the rhythm section.

And he could have used a friend, or at least some insightful *explication* of the university habitat. Before *The Invisible Dragon*, he was rarely invited to speak at universities. Had he been, he would have understood how fragile the prevailing intellectual armature actually was. It looked wonky to him, but everything academic did, so how was he to know that it was *really* wonky? How was he to know that critiques of the sort he had been writing, however apt or inept, would threaten the livelihoods of well-scrubbed young Americans and scruffy, dolorous Brits? It never occurred to him that he was tilting at windmills upon whose continuing rotation jobs, promotions, raises, tenures, homes, pools, skis, bikes, spas, Audis, and academic reputations were absolutely dependent.

Had he realized that the security of young families was

at stake, he should never have shot the dead sheriff. Having accidentally shot him already, he should have issued a public apology on the spot, but he just didn't get it. As a relic of the old school, all volunteer, heavily medicated, joyfully contentious art world, he had nothing to lose. He was anxious, alone, and appalled, but he was also having a new kind of fun, and he was right. The jet-setting *professores* were more at risk than he was. Now they are gone (though still drawing their salaries) and here the critic sits, watching toxic sleaze replace toxic purity, toxic hucksterism replace toxic academicism. *Bonne chance.*

He only wanted to restore some rigor to the discourse, to expand its reach and take it around the corner. In his view, the citadel of the Enlightenment had been pretty well demolished by thirty-five years of critique. All around him, new toilers were smashing chunks of its rubble into smaller chunks. He thought the scene of the wreck might serve as a building site. It seemed the exact moment for positive reimagination, lest reactionary neotribalism rise up from the ruins of modernity (which it did). Going in, he thought it would be minor surgery. Implant a little pagan neopragmatism *et voilà!* Then this alien creature, glistening with snot, burst from the patient's tummy. Then the patient, the philosophical discourse, died on the table, like a beloved old dog.

The critic was sad about this. During the sixties, he had been educated in the liberating discourse of French Structur-

alism. Levi-Strauss, Derrida, Barthes, Deleuze, and Foucault had opened a door for him. He had run through that door bound for Altamont and Mar y Sol, but he took his books with him into those bright, brutal afternoons. They were his talismanic texts. So consider the angstiness of his situation. Every night, just before sleep, the misshapen offspring of the writers who educated him were chasing him through the mist like Rasta zombies. And he was not alone in his haunt-edness. Even Frank Lentricchia, whose *After the New Criticism* introduced Structuralism to American academia, lifted his finger and said, "Uh, wait a minute!" Somehow, the delicate instrumentalities of continental thought had been transmuted by the American professoriat into a highfalutin, pseudo-progressive billy club with which to beat dissenters about the head and shoulders.

Professors claimed that "things had happened in the natural progression of things" while he was out (self-indulgently) play-ing rock and roll. None of them good, it seemed to him. Fou-cault's ruthless, timely dismantling of the human sciences had simply vanished. It had, in fact, been surgically amputated and a dumbed-down travesty of Frankfurt School sociology sewn on in its place. Barthes's dead author walked the steppes as an avatar of ethnic and sexual identity, replete with neediness and aura. Derrida's subtle deconstructions now empowered ham-fisted demolitions. Foucault's Panopticon and Lacan's gaze were untidily bundled into one lumpy paranoid concept (for survey

courses), with predictable theoretical consequences. Deleuze's meditations on the allusive "logic of sense" might never have been written.

The waft and flutter, the raison d'etre of our quiet attention to objects and texts, had disappeared. When he began reading widely and putting *The Invisible Dragon* together, he discovered that the waft and flutter been gone for a while. Everything was either this or that. Four books in, he realized that the neighborhood had gone to hell. Intellectual trash was scattered in the yard. Weeds were flourishing. He was slashing away, like one of those grimacing samurai warriors you see on Edo screens, raising his blade against the evil ghosts of his beloved ancestors. Even today, with the evil ghosts pretty much defunct, they still inhabit these writings as absent adversaries. The reader must reimagine them to make the tone feel right. So imagine seven white girls quietly chanting, "Pig! Pig! Pig! Pig!" in the front row of a lecture hall at Cranbrook Academy and you will get the idea.

This is always the problem with reading writing that has won an argument, even by default, as is the case here. Reading Ruskin's *The Stones of Venice*, one must reimagine the carping of his classicist detractors to understand the urgency of his prose. The absent ghosts of Sartre and Althusser haunt the writing of Foucault and Deleuze. They are never mentioned, but their predictable sour admonition hangs over the language like a pall of ash. It infects our reading like the

taste of sucking pennies. The critic's own detractors were a long way down the chute from Sartre and Althusser, but they remain sufficiently present in these essays to scuff the prose that he wrote in self-defense, and he is sorry about that. He will try to do better next time, but for now, with a chaste smile and a sleepy wave, he thanks you for reading his little book.

Enter the Dragon: On the Vernacular of Beauty

It would be nice if sometime a man would come up to me on the street and say, "Hello, I'm the information man, and you have not said the word 'yours' for thirteen minutes. You have not said the word 'praise' for eighteen days, three hours, and nineteen minutes."

Edward Ruscha, "The Information Man"

I was drifting, daydreaming really, through the waning moments of a panel discussion on the subject of "What's Happening Now," drawing cartoon daggers on a yellow pad and formulating strategies for avoiding punch and cookies, when I realized that I was being addressed from the audience. A lanky graduate student had risen to his feet and was soliciting my opinion as to what the "Issue of the Nineties" would be. Snatched from my reverie, I said, "Beauty," and then, more firmly, "The issue of the nineties will be *beauty*!" It was a total improvisatory goof—an off-the-wall, jump-start free association that rose unbidden to my lips from God knows where. Or perhaps I was being ironic, wishing it so but not believing it likely? I don't know, but the total, uncomprehending silence that greeted this modest proposal lent it immediate credence for me.

My interlocutor plopped back into his seat, exuding dismay. Out of sheer perversity, I followed beauty where it led, into the

silence. Improvising, I began updating Pater: "Beauty is not a *thing*," I insisted. "The Beautiful is a thing. In images, beauty is the agency that causes visual pleasure in the beholder, and, since pleasure is the true occasion for looking at anything, any theory of images that is not grounded in the pleasure of the beholder begs the question of art's efficacy and dooms itself to inconsequence!" This sounded provocative, but the audience sat there unprovoked. "Beauty" just hovered there, a word without a language, quiet, amazing, and alien in that sleek, institutional space—like a Pre-Raphaelite dragon aloft on its leather wings.

Plunging on, I said, "If images don't *do* anything in this culture, if they haven't *done* anything, then why are we sitting here in the twilight of the twentieth century talking about them? If they only do things after we have talked about them, then *they* aren't doing things, *we* are. Therefore, if our criticism aspires to anything beyond soft science, the efficacy of images must be the cause of criticism and not its consequence, the subject of criticism and not its object. And this," I concluded rather grandly, "is why I direct your attention to the language of visual affect—to the rhetoric of how things look—to the iconography of desire—in a word, to *beauty*!"

I made a *voilà* gesture for punctuation, but people were filing out. My fellow panelists gazed into the dark reaches of the balcony or examined their cuticles. I was surprised. Admittedly, it was a goof. Beauty? Pleasure? Efficacy? The Issue of the Nineties? Outrageous. But it was an outrage worthy of rejoinder—of a question or two, or a nod, or at least a giggle. Instead, I had inadvertently created

this dead zone, this silent abyss. I wasn't ready to leave it at that, but the moderator of our panel tapped on her microphone and said, "Well, I guess that's it, kids." So I never got off my parting shot. As we began breaking up, shuffling papers and patting our pockets, I felt sulky. (Swallowing a pithy allusion to Roland Barthes can do that.) And yet, I had no sooner walked out into the autumn evening than I was overcome by this strange Sherlock Holmesian elation. The dog had not barked in the night. The game was afoot.

I had put out my hand and discovered nothing—a vacancy that I needed to understand. I had assumed that from the beginning of the sixteenth century until just last week artists had been persistently and effectively employing the rough vernacular of pleasure and beauty to interrogate our totalizing concepts "the good" and "the beautiful." And now this was over? Evidently. At any rate, the critical vocabulary of beauty seemed to have evaporated, so I found myself muttering detective questions—Who wins? Who loses? *Qui bono?* I thought I knew the answer, but for the next year or so, I assiduously trotted out "beauty" wherever I happened to be, with whomever I happened to speak. I canvassed artists and students, critics and curators, in public and in private—just to see what they would say. The results were disturbingly consistent, and not at all what I would have liked.

. .

If you broached the issue of beauty in the American art world of 1988, you could not incite a conversation about rhetoric—or

efficacy—or pleasure—or politics—or even Bellini. You would instead ignite a conversation about the marketplace. That, at the time, was the "signified" of beauty. If I said, "Beauty," they said, "The corruption of the market," and I would say, "The corruption of the *market*?!" After thirty years of frenetic empowerment, during which the venues for contemporary art in the United Stated evolved from a tiny network of private galleries in New York into this vast, transcontinental sprawl of publicly funded, postmodern iceboxes? During which the ranks of "art professionals" swelled from a handful of dilettantes on the East Side of Manhattan into this massive civil service of PhDs and MFAs administering a monolithic system of interlocking patronage (which, in its constituents, resembles nothing so much as that of France in the early nineteenth century)? During which powerful corporate, governmental, cultural, and academic constituencies vied ruthlessly for power and tax-free dollars, each with its own self-perpetuating agenda and none with any vested interest in the subversive potential of visual pleasure? Under *these* cultural conditions, artists across this nation are obsessing about the *market*? Fretting about a handful of picture merchants nibbling canapés in Business Class? Blaming them for any work of art that does not incorporate raw plywood?

Under these cultural conditions, saying that the market is corrupt was like saying that the cancer patient has a hangnail. Yet manifestations of this *idée fixe* were pervasive—not least in the evanescence of the marketplace itself after thirty years of scorn for the intimacy of its transactions, but also in the radical discontinu-

ity between serious criticism of contemporary art and that of historical art. At a time when easily 60 percent of historical criticism concerned itself with the influence of taste, patronage, and the canons of acceptability upon the images that a culture produces, the bulk of contemporary criticism, in a miasma of hallucinatory denial, resolutely ignored the possibility that every form of refuge has its price and satisfied itself with grousing about "the corruption of the market." The transactions of value enacted under the patronage of our new, "nonprofit" institutions were exempted from this cultural critique, presumed to be untainted, redemptive, disinterested, taste-free, and politically benign. Yeah, right.

During my informal canvass, I untangled the "reasoning" behind this presumption. Art dealers, I found, "only care about how it looks," while the art professionals employed by our new institutions "really care about what it means." Easy enough to say. Yet even if this were true (and I think it is), I can't imagine any but the most demented naïf giddily abandoning an autocrat who monitors appearances for a bureaucrat who monitors your soul. Nor could Michel Foucault, who makes a variation of this point in *Surveiller et punir*. Foucault poses for us the choice that is really at issue here, between bureaucratic surveillance and autocratic punishment. Foucault opens his book with a grisly antique text describing the lengthy public torture and ultimate execution of Damiens, the regicide. He then juxtaposes this cautionary spectacle of royal justice with the theory of reformative incarceration propounded by Jeremy Bentham in his "Panopticon."

Bentham's agenda, in contrast to the king's public savagery, is ostensibly benign. It reifies the benevolent passion for secret control that informs Chardin's pictorial practice, and, like Chardin, Bentham *cares*. He has no wish to punish, merely to reconstitute the offender's desire under the sheltering discipline of perpetual, covert, societal surveillance in the paternal hope that, like a child, the offender will ultimately internalize that surveillance as "conscience" and start controlling himself as a good citizen should. However, regardless of Bentham's ostensible benignity (and in fact, because of it), Foucault argues that the king's cruel justice is ultimately more just—because the king does not care what we *mean*. The king demands from us the appearance of loyalty, the rituals of fealty, and, if these are not forthcoming, he destroys our bodies, leaving us our convictions to die with. Bentham's warden, on the other hand, demands our *souls*, and, on the off chance that they are not forthcoming, or *cannot* come forth into social normality, he relies on our having internalized his relentless surveillance in the form of self-destructive guilt and henceforth punishing and ultimately destroying ourselves.

These are the options Foucault presents. Within the art community, I would suggest, the weight of the culture is so heavily on Bentham's side that we are unable to see them as equally tainted. We are such obedient children of the Panopticon, so devoted to care, surveillance, and the redeemable *souls* of things, that we have transformed the complex choice between the king's savage justice and Bentham's bureaucratic discipline into a progressive, utopian

option: the "corrupt old market" versus the "brave new institution." Beauty in this scenario is despised because art dealers, like Foucault's king, traffic in objects and appearances. They value images that promise pleasure and excitement. Those that keep this promise are admitted to the court; those that fail are subject to the king's justice, which can be cruel and autocratic indeed. But there is another side to this coin. Art dealers are also like Foucault's king in that they do not care "what it means." As a consequence, radical content has traditionally flourished under the auspices of their profound disinterest.

The new, liberal institution, however, is not as cavalier about appearances as the market is about meaning. Like Bentham's benevolent warden, the institution's curators hold a public trust. They must look attentively and genuinely care about what artists mean, and what this meaning means in a public context—and, therefore, almost of necessity, they must distrust appearances. They must distrust the very idea of appearances, and distrust most of all the appearance of images that, by virtue of the pleasure they give, are efficacious in their own right. The appeal of these images amounts to a kind of ingratitude, since the entire project of the new institution is to lift the cruel burden of efficacy from the work of art and make it possible for artists to practice that "plain honesty" of which no great artist has ever been capable, nor ever wished to be. For those who would expose the inner soul of things to extended public scrutiny, sincerity—or the appearance of sincerity—is everything, and beauty is the bête noire, the snake in

the garden. It steals the institution's power, seduces its congregation, and elicits the dismay of artists who have committed themselves to the excruciating tedium of plain honesty.

The arguments such artists mount against beauty come down to one simple gripe: *Beauty sells*. Their complaints, of course, are couched in the language of academic radicalism, but they do not differ greatly from my grandmother's *haut bourgeois* prejudices against people "in trade" and people who get their names in the newspaper. Beautiful art sells. If it sells itself, it is an idolatrous commodity; if it sells something else, it is a seductive advertisement. Art is not idolatry, they argue, nor is it advertising. Idolatry and advertising, however, are indeed art, and the greatest works of art are always and inevitably a bit of both. (What then must we make of those unsalable works of art that the institution buys at such generous prices because they lack salable attributes? Is the institution itself not a marketplace?)

• •

My point here is that that there are issues worth advancing in images that are worth admiring—that the truth is never plain nor appearances sincere. To try to make them so is to neutralize the primary, gorgeous eccentricity of imagery in Western culture since the Reformation: the fact that it cannot be trusted, that images are always presumed to be proposing something contestable and controversial. This is the sheer, ebullient, slithering, dangerous fun of it. No image is inviolable in our dance hall of

visual politics. All images are potentially powerful. Bad graphics topple good governments and occlude good ideas. Good graphics sustain bad ideas and worse governments. The fluid nuancing of pleasure, power, and beauty is *serious business* in this culture. It has been since the sixteenth century, when dazzling rhetorical innovations of Renaissance picture-making enabled artists to make speculative images of such authority that power might be bestowed upon them, privately, by their beholders, rather than its being assigned by the institutions of church and state.

During the Renaissance, for the first time in history, the power of priestly and governmental bureaucracies to assign meaning to images begins to erode, and the private encounter between the image and its beholder takes on the potential of changing the public character of institutions. Images become mobile at this point, and irrevocably political. Henceforth, for more than four centuries subsequent to the rise of easel painting, images *argue* for things—for doctrines, rights, privileges, ideologies, territories, and reputations. Throughout this period, a loose, protean collection of tropes and figures signifying "beauty" functions as the *pathos* that recommends the *logos* and *ethos* of visual argumentation to our attention. The task of beauty is to enfranchise the audience and acknowledge its power—to designate a territory of shared values between the image and its beholder and then, in this territory, to advance an argument by valorizing the picture's problematic content. Without the urgent intention of reconstructing the beholder's view of things, the image has no reason to exist, much

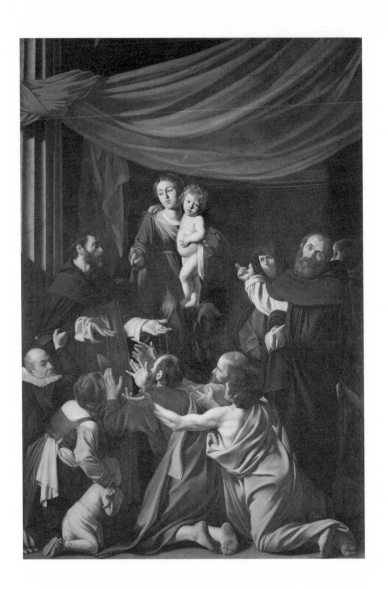

less to be beautiful. The comfort of the familiar always bears with it the frisson of the exotic, and the effect of this conflation, ideally, is persuasive excitement—visual pleasure. As Baudelaire says, "the beautiful is always strange," by which he means, of course, that it is always strangely familiar and vaguely surprising.

Thus Caravaggio, at the behest of his masters, deploys the exquisite hieratic drama of *The Madonna of the Rosary* to lend visual appeal and corporeal authority to the embattled concept of the intercession of the priesthood. He demonstrably succeeds, and not just in pleading his masters' case. He also imposes the urbane glamour of his own argumentation onto that doctrine. Today, as we stand before *The Madonna of the Rosary* in Vienna, we pay homage to a spectacular souvenir of successful visual litigation, an old warhorse—in this case, a thoroughbred—put out to pasture. The image is quiet now; its argumentative frisson has been neutralized, the issue itself drained of ideological urgency, leaving only the cosmetic superstructure of that antique argument, just visible enough to be worshipped under the frayed pennants of "humane realism" and "transcendent formal values" by the proponents of visual response.

Before we genuflect, however, we must ask ourselves if Caravaggio's "realism" would have been so trenchant, or his formal ac-

complishment so delicately spectacular, had his contemporary political agenda, under the critical pressure of a rival church, seemed less urgent? And we must ask ourselves if the painting would even have survived until Rubens bought it had it not somehow expedited that agenda? I doubt it. We are a litigious civilization and we do not like losers. The history of beauty, like all history, tells the winner's tale, in the great mausoleums where images like Caravaggio's, having done their work in the world, are entombed— and where, even hanging in state, they provide us with a ravishing and poignant visual experience. One wonders, however, whether we do well to ground our standards for the pleasures of art in the glamorous *tristesse* we feel in the presence of these institutionalized warhorses—whether contemporary images are really enhanced by being interned in a museum at birth and attended as one might a movie, whether there might not be work for them to do in the world among the living.

For more than four centuries, the idea of "making it beautiful" has been the keystone of our cultural vernacular—the lover's machine gun and the prisoner's joy—the last redoubt of the disenfranchised and the single direct route, without a detour through church or state, from the image to the individual. Now that lost generosity, like Banquo's ghost, is doomed to haunt our discourse about contemporary art—no longer required to recommend images to our attention or to insinuate them into vernacular memory, no longer welcome even to try. The route from the image to the beholder now detours through

an alternative institution, ostensibly distinct from church and state. It is not hard, however, to detect the aroma of Caravaggio's priests as one treads its gray wool carpets or cools one's heels in its arctic waiting rooms. One must suspect that we are denied the direct appeal of beauty for much the same reason that Caravaggio's supplicants were denied direct appeal to the Virgin: to sustain the jobs of bureaucrats. Caravaggio, at least, *shows* us the Virgin, in all her gorgeous autonomy, before instructing us not to look at her and redirecting our guilty eyes to that string of wooden beads hanging from the priest's fingers. The priests of the new church are not so generous. Beauty has been banished from their domain and we are left counting the beads and muttering the texts of academic sincerity.

• •

As luck would have it, while I was in the midst of my informal survey, the noisy controversy over exhibiting Robert Mapplethorpe's pornographic photographs in public venues provided me a set-piece demonstration of the issues. At first, I was optimistic, even enthusiastic. This uproar seemed to be one of those magic occasions when the private visual litigation that good art conducts might expand into the more efficacious litigation of public politics—and challenge some of the statutory restrictions on the conduct that Robert's images celebrate. I was wrong. The American art community, at the apogee of its power and privilege, chose to play the ravaged virgin, flinging itself prostrate

across the front pages of America and fairly daring the fascist heel to crush its outraged innocence.

Moreover, this community chose to ignore the specific legal transgressions celebrated in Robert's photographs in favor of the "higher politics." It came out strenuously in defense of the status quo and all the perks, privileges, and public money it had acquired over the last thirty years, and did so under the tattered banner of "free expression"—a catchphrase that I presumed to have been largely discredited by the feminist critique of images. After all, once a community acquiesces in the assumption that *some* images are certifiably toxic, it opens the door to the toxification of *any* image.

Finally, hardly anyone considered, even for a moment, what a stunning rhetorical triumph the entire affair signified. A single artist with a single group of images had somehow overcome the aura of moral isolation, gentrification, and mystification that surrounds the practice of contemporary art in this nation and directly threatened those in actual power with his celebration of marginality. It was an extremely cool moment, I thought, and all the more so because it was the *celebration* and not the marginality that made these images dangerous. Simply, it was their rhetorical acuity and their direct enfranchisement of the secular beholder. It was, exactly, their beauty that lit the charge—and in this area, I think, you have to credit Senator Jesse Helms. In his antediluvian innocence, he at least saw what was there, understood what Robert was proposing, and took it, correctly, as a direct challenge

to everything he believed in. The senator may not have known much about art, but rhetoric was his business and he didn't hesitate to respond to the challenge, as, one would hope, he had a right to. Art is either a democratic political instrument, or it is not.

So it is not the fact that men are depicted having sex in Robert's images. At the time, they were regularly portrayed doing so on the walls of private galleries and publicly funded "alternative" spaces all over the country. Thanks to the cult of plain honesty, abjection, and sincere appearance, however, they were not portrayed as doing so *persuasively,* powerfully, beautifully. Robert makes it beautiful. He appropriates a Baroque vernacular of beauty that predates and, clearly, outperforms the puritanical canon of visual appeal espoused by the therapeutic institution. He poses what, for the institution, is an unanswerable question: Should we really look at art, however banal, because looking at art is somehow good for us, while ignoring any specific good that the individual work or artist might propose to us?

The habit of subordinating the artist's politics to the "higher politics of expression" makes perfect sense in the mausoleums of antiquity, where we can hardly do otherwise. It is, perhaps, "good" for us to look at *The Madonna of the Rosary* without blanching at its Counter-Reformation politics, because those politics are dead. It may be good for us, as well, to look at a Sir Thomas Lawrence portrait and "understand" his identification of romantic heroism with the landed aristocracy. It is insane and morally ignorant, however, to confront the work of a liv-

ing (and at that time, dying) artist as we might the artifacts of lost Atlantis, with forgiving connoisseurship—to mildly "appreciate" his passionate, partisan, and political celebrations of the American margin. In our mild appreciation, we refuse to engage the argument of images that deal so intimately with trust, pain, love, and the giving up of the self.

Yet this is exactly what is expected and desired, not by the government, but by the art establishment. It is a matter of "free expression," and thus the defense of the museum director prosecuted for exhibiting the images was conducted almost entirely as a defense of the redemptive nature of formal beauty and the critical virtue of oversight and surveillance. The "sophisticated" beholder, the jury is told, responds to the elegance of the form regardless of the subject matter. Even so, this beholder must be "brave" enough to look at "reality" and "understand" the sources of that formal beauty in the artist's tortured private pathology. If this sounds like the old patriarchal doodah about transcendent formal values and humane realism, it is, with the additional fillip that, in the courts of Ohio, the source of beauty is now taken to be, not the corruption of the market, but the corruption of the *artist*. Clearly, all this litigation to establish Robert Mapplethorpe's "corruption" would have been unnecessary if his images *acknowledged* their corruption and thus qualified for our forgiveness and understanding. But they do not.

There is no better proof of this than the fact that, while the Mapplethorpe controversy is raging, Francis Bacon's retrospec-

tive is packing them in at the Los Angeles County Museum of Art, and Joel-Peter Witkin is exhibiting in constitutional serenity. Bacon's and Witkin's images speak a language of symptoms, of flagrant corruption, that is profoundly tolerable to the status quo. Bacon and Witkin mystify Mapplethorpe's content, aestheticize it, localize it, and further marginalize it as "artistic behavior," with signifiers denoting angst, guilt, and despair. So, clearly, it is not the thing portrayed that challenges us in Robert's images. It is his impudent resort to *praise* of the margin (not some vague critique of the mainstream) that challenges the powers that be. Critique of the mainstream ennobles the therapeutic institution's ostensible role as shadow government and disguises its unacknowledged mandate to neutralize dissent by first ghettoizing and then mystifying it. Confronted by images like Mapplethorpe's that appeal directly to the beholder and disdain the therapeutic institution's umbrella of "care," the institution is disclosed for what it is: the moral junkyard of a pluralistic civilization.

Yet the vernacular of beauty, in its democratic appeal, remains a potent instrument for change. Mapplethorpe uses it, as does Warhol, as does Ruscha, to engage individuals within and without the cultural ghetto in arguments about what is good and what is beautiful. And they do so without benefit of clergy, out in the street, out on the margin where we might, if we are lucky, confront that information man with his reminder that we have not used the word "praise" for eighteen days, three hours, and nineteen minutes.

Nothing like the Son: On Robert Mapplethorpe's *X Portfolio*

When I think of what sort of person I would most like to have on retainer, I think it would be a boss.

Andy Warhol, *The Philosophy*

I spend five minutes at the outside glancing through Robert Mapplethorpe's images for defensible allusions to other works of art. I come up with Leonardo, Correggio, Raphael, Bronzino, Caravaggio, Ribera, Velázquez, Chardin, Reynolds, Blake, Gérôme, Fantin-Latour, and a bunch of photo guys. An art historian could doubtless do better but would probably come to the same conclusion: These images are too full of art to be "about" it. They may live in the house of art and speak the language of art to anyone who will listen, but almost certainly they are "about" some broader and more vertiginous category of experience to which art belongs—although we rather wish it didn't.

• •

Consider Caravaggio's *The Incredulity of Saint Thomas* (1601). With its background cloaked in darkness and its space pitched

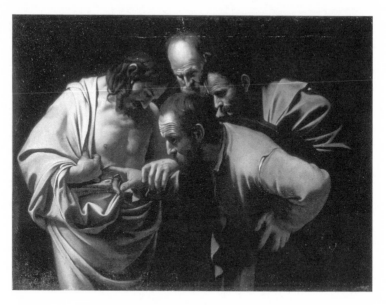

CARAVAGGIO *The Incredulity of Saint Thomas.* 1601.
VECCHIA POSTA, FLORENCE. PHOTO: ALINARI/ART RESOURCE, NY.

out into the room, the painting recruits us to be complicit spec-
tators as the resurrected Christ calmly grasps the incredulous
Thomas by the wrist and guides the saint's extended forefinger
into the wound in his side. Two other disciples crowd forward,
leaning over Thomas's shoulder to observe more closely; and
we are lured forward as well, by the cropped, three-quarter-
length format of the painting that, like a Baroque zoom, or

like Christ's hand on our wrist, gently but firmly draws us into the midst of the spectacle. Just as Christ opens his wound to Saint Thomas, Caravaggio (presuming to persuade us from our own doubt and lack of faith) opens the scene to us, in naturalistic detail. And we, challenged and repelled by the artist's characterization of us as incredulous unbelievers (and guilty in the secret knowledge that, indeed, we are), must respond with honor, with trust, by *believing*—and not, like Thomas, our eyes. (*To look* is to doubt.) To free ourselves from guilt, and from Caravaggio's presumption of our incredulity, we must transcend the gaze, see with our hearts, and acquiesce to the gorgeous authority of the image, extending our penitential love and trust to Christ, to the Word, to the painting, and, ultimately, to Caravaggio himself.

Thus do "the religion of Christ" and the "religion of art" erotically infect one another. For just as Christ trusts Saint Thomas and suffers himself to be intimately touched, we trust the image and suffer ourselves to be intimately touched—taking beauty as the signature of the image's grace and beneficence. And just as Christ, by his submission, ennobles his disciple and controls him, so we ennoble the image and control it in our submission. In doing so, we demonstrate that, even though we may be, in all other respects, nothing like the Son, we may still, like him, give ourselves up, trust ourselves to be humbled—by God, by art, by others—and, full of guilt, contract the conditions of our own submission. In that submission we, like him,

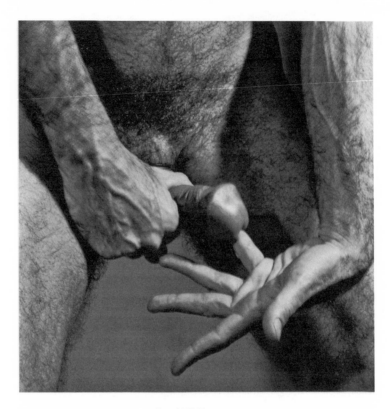

ROBERT MAPPLETHORPE *Lou, N.Y.C., 1978*

© THE ROBERT MAPPLETHORPE FOUNDATION.
COURTESY OF ART + COMMERCE.

may redeem our guilt and dominate, triumph before the arrested image of our desire, in an exquisite, suspended moment of pleasure and control.

. .

Or so Robert Mapplethorpe would have had us believe—he who began in the bosom of the church and left it to rig out his own language of redemption on the street, to fashion a sleek patois of "classical" and "kitsch" that flirted with the low and disarmed the high with its charm. Over the years, he would cultivate this dialect of tawdry beauty, refine it to the point of transparency, and extend the franchise of his work beyond the purview of the art world and its institutions. Then, when those bastions of culture finally deigned to gather him in, Robert's oeuvre overrode all institutional disclaimers and continued to make accessible that which it had been making accessible all along. Very straightforwardly. People were shocked. Institutions flinched, moral guardians went berserk, and Robert died, leaving us with a repertoire of images that are as hard to ignore as they are impossible to misconstrue.

The images were all about transgression, of course, about paying for it in advance with the suspension of desire—and loving it. But they were not about transgression for its own sake. Those whom the world would change must change the world, and Robert's entire agenda, I think, derived from his understanding that, if one would change the world with art,

one must change a great deal of it. Thus, the axiom that *the meaning of a sign is the response to it* had, for him, a quantitative as well as a qualitative dimension. He wanted them all—all those beholders—and, wanting them, he saw the art world for what it was—another closet.

It was not enough for him that his images meant well, that they enfranchised "the quality" (although he hoped they would). They must also mean *a lot*, for good or ill—because when push came to shove, the power to tip the status quo could only be bestowed upon images by representatives of that status quo, in the street and in the corridors of power. So he embarked upon a dangerous flirtation. Sailing as close to the wind as Wilde, he embraced the double irony of full disclosure and made the efficacy of his images a direct function of their power to enfranchise the noncanonical beholder—to enfranchise, ultimately, that senator from North Carolina and insist upon his response. Because, in truth, if the senator didn't think an image was dangerous, it wasn't. Regardless of what the titillated cognoscenti might flatter themselves by believing, if you dealt in transgression, insisted upon it, it was always the senator, *only* the senator, the Master of Laws, the Father, whose outrage really mattered.

. .

I saw Robert's *X* images for the first time scattered across a Pace coffee table at a cocaine dealer's penthouse on Hudson

Street. In that context they were just what they would be—a sheaf of piss-elegant snapshots, photos the artist made when he wasn't making art—*noir* excursions into metaphysical masochism and trading cards for cocaine. Handsome and disturbing images, to be sure, but as long as they remained in private circulation, clandestine artifacts, and peripheral texts at best—like Joyce's diaries or Delacroix's erotica. Today the images in the *X Portfolio* are "fine photographs" and better for it. They hang as authorized images alongside their pornological predecessors and ancillaries, and that work is richer and rougher for their company.

Even so, hanging there on the wall amid their sleeker siblings, these images seem contingent, their artistic legitimacy so newly won that you almost expect to see sawdust on the floor as you would at Spike. They seem so obviously to have come from someplace else, down by the piers, and to have brought with them, into the world of ice-white walls, the aura of knowing smiles, bad habits and rough language in smoky, crowded rooms with raw brick walls, sawhorse bars, and hand-lettered signs. They may be legitimate, but like my second cousins Tim and Duane, who have paid their debt to society, they are still far from respectable. Family and friends divide along lines of allegiance and will doubtless continue to. This family feud, I think, rather than any parochial outcry over their content, best defines the difficulty of the *X Portfolio* images. The real, largely unarticulated questions surrounding them derive less from

what they show about sex than from what they say about art. If they *are* art—and even Robert's putative supporters seem willing, on appropriate occasions, to assign them to second-class citizenship in Robert's oeuvre.

It is an antique quarrel, really, dating from the dawn of the Baroque. If I may draw a comparison without implying an equation, let me suggest that these *noir* photographs bear the same relationship to the rest of Robert's work that Shakespeare's Sonnets do to the body of his endeavor. Certainly the Sonnets, like the *X* images, have persistently served as a watershed for criticism, separating the sheep from the goats, as it were—and, if we believe (as there is every reason to) that the Quarto edition of the Sonnets was indeed suppressed, they have done so from the outset. In any case, throughout their four-hundred-year vogue, these poems have been cited alternately as Shakespeare's crowning laurel and as evidence of his feet of clay—with no lesser lights than Dr. Johnson, Coleridge, Wordsworth, Byron, and Bernard Shaw opting for the latter and offering some version of Henry Hallam's famous plaint that "it is impossible not to wish that Shakespeare had not written them." Anyone who has been privy to discussions of the *X Portfolio* among "connoisseurs of fine photography" is familiar with this sentiment.

Both the Sonnets and the *X Portfolio*, it seems, suffer and benefit in equal parts from the taint of marginal legitimacy. Both projects are bastard offspring, conceived in the intimacy of pri-

vate discourse and only later elevated in status. This persistently arouses suspicions that their formal exigencies and perfervid intensities are less the product of "artistry" than a by-product of their suboptimal secular agendas, which (on the candid evidence of texts and images) involves some thoroughgoing, nonfictional sexual improprieties on the part of both Artist and Bard. Depending on the commentator, of course, these candid disclosures either illuminate the more public production or infect it with an extratextual aura of feverish disquiet. So the quarrel continues. It would not continue quite so strenuously, I think, nor the issues of legitimacy and sexual impropriety seem quite so critical, if the works in question were not so self-enclosed—if there were some outside position, some discrete "cultural" vantage point from which we might attend them. But there is not. Like *The Incredulity of Saint Thomas*, both the Sonnets and the *X Portfolio* compel our complicity and characterize us, in the act of attention, in some relatively uncomfortable ways.

In a typical sonnet, for instance, the actual William Shakespeare addresses his actual mistress (of whatever gender) and characterizes their relationship in one of two ways. He either describes his mistress to "herself" ("For I have sworn thee fair and thought thee bright, / who art as black as hell and dark as night"), or he describes himself to his mistress ("Being your slave, what could I do but tend / upon the hours and times of your desire?"). The paired roles that the sonnet makes possi-

ble—speaker and spoken to, beholder and beheld, describer and described, dominant and submissive—are all spoken for. They are exhausted and enclosed in the primary, binary transaction between the poet and his mistress, an enclosure whose rapt obsessiveness is succinctly demonstrated by a quatrain from Sonnet XXIV:

> Now see what good turns eyes for eyes have done:
> Mine eyes have drawn thy shape, and thine for me
> Are windows to my breast, wherethrough the sun
> Delights to peep, to gaze therein on thee.

Here, excepting the Caravaggesque light source, there is no external reference, no neutral position outside the transaction. The words we hear are being spoken by a real person to a real person; the images we see are being shown by someone "other" to someone else, more other still, and both are intertwined in the act of beholding. There is simply no allowance made for an "objective cultural auditor"—which is not to say that we cannot *invent* one, only that it is nearly impossible to do so without entering into uneasy complicity with one participant or the other in the actual, factual narrative of desire of which the language is a trace. In other words, we have to trust someone, give ourselves up somehow to one position or the other.

What I am suggesting, of course, is that our relationship to the photographs in the *X Portfolio* is easily as problematic, if not more so. The role of "objective cultural auditor" that we pre-

sume to inhabit—on account of the gallery setting—may not exist, since there can be little doubt that the arrested images in these dark photographs, like those in the Sonnets, are traces of lost erotic transactions in which the lover describes his mistress to his mistress, or himself to "her." He freezes that moment of apprehension as a condition of their intercourse. Thus all of the rhetorical positions implied by the photographs are, again, exhausted in the suspended transaction between *beholder* and *beheld*; the comfortable role of "art beholder" is written out of the scenario, as we are cast in roles before the image that we are unaccustomed to acknowledging—at least in public.

All of this would tend to confirm the veiled suspicions of those commentators who have approached the *X Portfolio* like church ladies at La Scala, exuding sophistication but wary of seduction, anxious about their pleasure and fearful of being manipulated to sexual rather than cultural ends by the flagrant ornamental display, suspicious that the "formal armature" of the imagery has been tainted somehow by its origins in situational erotics. This anxiety, it seems to me, is perfectly justified, although the offending double-entendre is hardly deplorable. It is, in fact, absolutely irremediable and, more or less, the point of Robert Mapplethorpe's photography. The erotic and the aesthetic potential derive from *exactly* the same rhetorical language and iconographic display, just as they do in Titian's *Venus d'Urbino*, and beyond the proclivity of the beholder, there is no way of sorting them out. They amount to no more (or

less) than alternate readings that are as inextricably intertwined in our perception of them as are the spiritual and aesthetic rhetorics of *The Incredulity of Saint Thomas* (which are intertwined as well with a rather queasy, necrophilic subtext).

Simply put, the rituals of "aesthetic" submission in our culture speak a language so closely analogous to those of sexual and spiritual submission that they are all but indistinguishable when conflated in the same image. Or, to state the case hypothetically: we have, for nearly a hundred years, hypostasized the rhetorical strategies of image-making and worshipped their mysteries under the pseudonym of "formal beauty." We are so conditioned to humbling ourselves before the cosmetic aspects of the image that, when these rhetorical strategies are actually *employed* by artists like Caravaggio or Mapplethorpe to propose spiritual or sexual submission, we cannot distinguish the package from the prize, the vehicle from the payload, the "form" from the content. So now, in our culture, the scenarios of dominance by submission that characterize our participation in "high art" and "high religion" and "classical masochism" as systems of desire, all intersect in the topoi of the "arrested image," which is their common attribute, and the centerpiece of their ritual theater. Once we acquiesce in the reification of formal values, questions of whether one manifestation is "better" than another, derives from another, is displaced by another, or transforms itself into another, become inexplicable and irrelevant.

All these scenarios should be considered equally redemptive and perverse—and certainly, given the "arrested image" and the proclivity of the beholder, they are all possible—although usually, in any given context, one is more probable than the others. Images like Robert Mapplethorpe's *X Portfolio* and texts like Shakespeare's *Sonnets,* however, tilt the altars at which we worship by making them *all* seem probable. In doing so they collapse and conflate the hierarchies of our response to sex, art, and religion and, in the process, generate considerable anxiety. So we may, according to our wont or desire, read the *X Portfolio* in the language of religion, of sexuality, or of formalist aesthetics, but we must do so knowing that the artist himself positioned his images exactly at their intersection. The categories are our own, and our culture's—and the images themselves, under the pressure of our categories, don't seem be *anything* in particular. They just seem to be *too much.* We are left asking, Why do I submit to this gritty, Baroque image of a man's arm disappearing into another man's anus? And choose to speculate upon it? And why must Robert have submitted to the actual, intimate, aromatic spectacle? And chosen to portray it? And finally, why did the supplicant kneel and submit to having a lubricated fist shoved up his ass? And choose to have himself so portrayed?

And the answer, of course, in every case, is pleasure and control—but deferred, always deferred, shunted upward through concentric rituals of trust and apprehension, glimmering

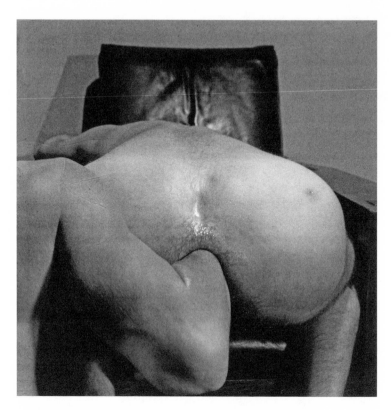

ROBERT MAPPLETHORPE *Helmut and Brooks, N.Y.C., 1978.*

© THE ROBERT MAPPLETHORPE FOUNDATION.
COURTESY OF ART + COMMERCE.

through sexual, aesthetic, and spiritual manifestations, resonating outward from the heart of the image through every decision to expand the context of its socialization, suspending time at every point, postponing consummation, and then, suddenly—at the apogee of its suspense—swooping back down, circling rapidly inward upon an image now flickering in wintry glamour at the intersection of moral suffering and spiritual ecstasy, where the rule of law meets the grace of trust. It is a nothing image, really, not even an idea—but so palpably corporeal on the one hand, and so technically extravagant on the other, that it seems on the verge of exploding from its own internal contradictions. Or just disappearing when we look away.

Prom Night in Flatland:
On the Gender of Works of Art

For spirits, freed from mortal Laws, with ease
Assume what Sexes and Shapes they please.

Alexander Pope, *The Rape of the Lock*

As a stepchild of the Factory, I am certain of one thing: *images can change the world*. I have seen it happen. I have experienced the "Before and After," as Andy might say, so I know that images can alter the visual construction of the reality that we all inhabit. They can revise the expectations we bring to that reality and the priorities we impose upon it. I know, further, that these alterations can entail profound social and political ramifications. So, even though I am an art critic now and occupationally addicted to the anxiety of change, I cannot forget that there should be more to it than that. There is change, and there is change. When change takes on the innervating aspect of Brownian agitation nothing is really changing. When the "difficulty" of the images one writes about stops being an occasion to upgrade the efficacy of one's critical practice, when this difficulty becomes rote and repetitive, no more than a demand to practice criticism as preached, there are obviously forces in play that resist change

and refinement. Under these conditions, one can become a bit contemplative about the business of connecting the dots with regard to art objects that present themselves as strategized invitations to cite the talismanic theoretical texts that inspired them in the first place.

In fact, when change stops generating anxiety by challenging one's language of value, when works of art become simple occasions for fashionable *écrits morts*, one cannot suppress a growing sensitivity to those aspects of contemporary image-making that do not change and, by not changing, make substantial and more anxious change less likely. For myself, I have become increasingly amazed and dismayed at the persistence of dated modernist conventions concerning the canonical status of "flatness" and the inconsequence of "beauty" in twentieth-century painting. In my view, the linguistic properties implicit in the "negativity" of illusionistic space—its metaphorical "absence"—and the rhetorical properties latent in our largely unarticulated concept of beauty should more than outweigh whatever academic reservations might still accrue to them.

It was, after all, the invention of illusionistic space that bestowed upon the visual language of European culture the attributes of "negativity" and "remote tense," which are generally taken to distinguish human languages from the languages of animals. These properties make it possible for us to lie, to imagine convincingly in our speech, to assert what we are denying, and to construct narrative memory by displacing the locus of our assertions into

a past or a future—into a conditional or subjunctive reality. For four centuries visual culture in the West possessed these options and exploited them. Today we are content to slither through the flatland of Baudelairian modernity, trapped like cocker spaniels in the eternal, positive presentness of a terrain so visually impoverished that we cannot even *lie* to any effect in its language of images—nor imagine with any authority—nor even remember.

Such is the Protestant hegemony of this antirhetorical flatness in the practice of painting that contemporary artists have been forced to divert their endeavors into the less nuanced realms of performance, dance, text, photography, video, sculpture, and installation design in order to exploit the semantic spaces and rhetorical felicities that are still available in literary and theatrical practice. These contemporary flights into mechanical and literal representation, of course, only crudely approximate effects that were effortlessly available to Titian on his worst day. Film, video, photography, and installation can only mimic real space in an art context. Veronese, Titian, and Tiepolo had access to molded and nuanced imaginary space that speaks its own language. The perspectival square grid in Veronese's *Marriage at Cana* is stretched into a grid of horizontal rectangles that opens the picture into a disconcerting and capacious space that could only exist in painting—and consequently no longer exists in art.

This refusal on the part of contemporary artists to exploit and manipulate negative space, or even to use it, is a peculiar form of self-denial and not a simple one. To crack the lid a little, I would

like to suggest that the tenacity of taboos concerning "feminine" space and "feminine" appeal derive from subliminal and largely vestigial ideas about the gender of the work of art itself (as it is characterized by the language in which we speak of it and the relationship we presume to maintain with it). These taboos would seem to be maintained in esteem pretty much by default, based partly on the reluctance of heterosexual artists and critics to challenge them and in so doing to risk the dread charge of bourgeois effeminacy—since we all know that today, in the Balkanized gender politics of contemporary art, the self-consciously "lovely," that is, the "effeminate" in art, is pretty much the domain of the male homosexual. I will not digress on this blatantly sexist and homophobic situation except to note that it is largely validated by the patriarchal art-historical scenarios implied by high-modernist criticism like Frank Stella's *Working Space* and Michael Fried's *Absorption and Theatricality*—both of which, I hasten to note, are, for what they are, very good indeed. (One may, I think, admire the subtlety and acuity of Fried's and Stella's insights into the vagaries of historical picture-making without buying into their critical agendas.)

This genre of teleological criticism inevitably portrays the rise of premodern art toward exalted modernism as a virile struggle with, and ultimate triumph over, the effeminacy of illusionistic space and all other devices designed to "ingratiate" the beholder. Stella addresses the "masterful" Caravaggesque inversion of passive Mannerist recession into aggressive Baroque intrusion; Fried

addresses the success of late-eighteenth-century French painters like Greuze, Vernet, Van Loo, and early David in dropping an invisible "fourth wall" down the picture plane, chastely sealing off the erotic, participatory extravagance of Rococo space from the viewer—while occasionally depositing an artist-created simulacrum of the viewer inside the hermetically sealed pictorial atmosphere, thus imposing what Fried calls the "supreme fiction" that the beholder is simply not there. Fried implies, and correctly, I think, that this device is designed to cast the nonparticipatory observer in the role of objective moral observer. Its less redemptive by-product is that it recasts the viewer in the role of an irresponsible, alienated, elitist voyeur. This is the aspect of the "supreme fiction" that Fragonard exploits so seductively in his *haut* pornography and that Chardin, more ominously, employs to provide us with secret glimpses (through his one-way "sociological lens") of the lower orders in their most private moments.

The critical point to be made here is that both Stella and Fried develop their arguments by reconstituting the traditional High Renaissance ménage à trois of work, artist, and beholder. At its most sophisticated, the sixteenth-century dynamic of perception assumed a bond of common education, religion, and gender (male) between the artist and the beholder. If anything, the artist—a mere artisan—was regarded as the less entitled of this duo, but conventionally, at least, these comrades were presumed to stand side by side confronting the otherness of the work's rapidly receding pictorial space. This illusion of recession evoked

PROM NIGHT IN FLATLAND

both the prospect of a heavenly Arcadia and the mystery of an "erotic other." The invitation of the open picture plane offers both a window into spiritual succor and the prospect of a "heavenly cunt" (*potta del cielo*) to the beholder, who might gain access via the blessed virgin or the symbolic maidenhead, according to his Neoplatonic proclivity.

This simultaneous maintenance of spiritual and carnal senses in works of art is a crucial aspect of the freewheeling Renaissance resolution of classical and Christian antiquity. It enabled the Renaissance artist to exploit both the secular corporeality of classical imagery and the theological imperatives associated with the doctrine of the incarnate word. Without the ambience of this perpetual double-entendre and its invitation to covert reading, Ovid would have been blasphemous, Raphael a little dull, and Bernini's *Saint Theresa* all but inexplicable. The High Renaissance ménage à trois makes what we call "modern art" all but impossible.

So, in Stella and Fried, the work-artist-beholder triangle is demobilized. The bond of commonality between artist and beholder is dissolved. The presumption that the two parties have equal insight into the mysteries of the work is dispensed with, as the artist is invested with prophetic singularity. The bond of a work of art with its artist is now assessed in terms of "strength," its bond with the beholder in terms of "weakness." Insofar as I have been able to tease meaning out of usage, "strength," in contemporary criticism, is a straightforward euphemism for the medieval concept of "virtue," a gender-sensitive term of approbation connoting virility

and power in men and chastity in women; by analogy, "weakness" implies effeminacy in men and promiscuity in women. In the restructured modernist dynamic, the role of the beholder is to be dominated and awestruck by the work of art, which undergoes a sex change and is recast as a simulacrum of the male artist's autonomous, impenetrable self.

This reconfigured ménage is also reflected by a shift in the cautionary mythology of artistic creation that takes place around the end of the eighteenth century. In the traditional myth of Pygmalion, the artist's romantic involvement with the otherness of his creation brings it to life in a secular miracle of the word made flesh. By the beginning of the nineteenth century, this myth has been superseded by that of Mary Shelley's *Frankenstein*. Pygmalion's erotic nymph is replaced by Dr. Frankenstein's monster—a powerful, autonomous simulacrum of its creator's promethean, subterranean self, wreaking cold judgment and vengeance on all who behold it. It is not insignificant, I think, that the dominant female member of the circle of English Romantics would be the first of them to glimpse the dark side of the Romantic predisposition to construe works of art as radical, autonomous twins of their alienated auteurs.

Under these revised priorities, the validity of receding illusionistic space in painting was immediately called into question. This imaginary space had been traditionally, and quite rightly, perceived as "community property," shared by the work, its creator, and its beholder. The new, modern priorities insisted that no

such community existed. The flat picture plane came to represent the property line dividing the mundane world of the beholder from the exalted territory of the artist's incarnate prophecy. Thus, when Stella celebrates Caravaggio's retailoring of the traditional ménage à trois into a pas de deux, he credits the artist with transforming his studio into a "cathedral of the self." In doing so, he voices his silent disapproval and dismissal of a large tradition of artists like Warhol, Tiepolo, and the generous Boucher who risked the charge of frivolous effeminacy by transforming *their* studios and their art into promiscuous confluences of the other.

From an artist's point of view, this exclusive bonding of artist and work might seem a wholesome state of affairs. From the point of view of a professional beholder like myself (whose job is establishing "relationships" with works of art), it is somewhat less so. Insofar as Stella and Fried's historical reflections accurately mirror the character of contemporary art (and to a large extent they do), I may almost certainly expect, as I walk into a gallery, to confront either a bunch of autonomous icons pretending that I am not present or a covey of "difficult" autodidacts intruding into my space and making theoretical demands on me or, worse, some bits of paper and string whose creator clearly expects me to bring more wit and mercy to the work than I possess. Over years of such confrontations, it has become increasingly clear to me that our twentieth-century characterization of the work of art as a ravishing, autonomous entity that we spend our lives trying to understand, that makes demands on us while pretending that we are not there,

is simply a recasting of the work of art in the role of the remote and dysfunctional male parent in the tradition of the biblical patriarch. Even art critics deserve respite from this sort of abusive neglect.

• •

It should be clear by now that the structure of my argument is threefold. First, I am suggesting that over the last four-hundred-odd years, the "work of art," and particularly the painting, has undergone a number of perceptual gender shifts. The demotic of Vasari's time invested work with attributes traditionally characterized as "feminine": beauty, harmony, generosity. Modern critical language validates works on the basis of their "masculine" characteristics: strength, singularity, autonomy. Second, I am suggesting that the dynamics of these gender shifts presuppose that the gender of the artist and the beholder are *not* shifting, which of course they are. Third, I am suggesting that, since the rhetoric of flatness applies primarily to painting, the "death of painting" in the late 1960s and the rise of three-dimensional, photographic, and time-based genres marked nothing more than a growing discomfort with the mythologies of "modern painting," which in fact have less to do with the paintings themselves than with the critical language used to defend them. These conditions would seem to invite a more radical rethinking of the gender dynamics inherent in our perception of contemporary and historical art than any of us probably have time for.

I should like to be clear on two other issues. First, the question

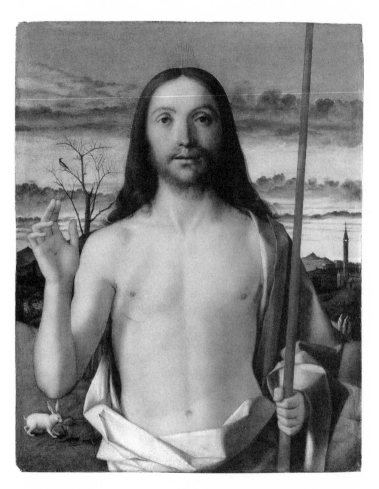

GIOVANNI BELLINI *Christic Blessing.*

TEMPERA, OIL, AND GOLD ON PANEL, CA. 1500.
KIMBELL ART MUSEUM, FORT WORTH, TX.
PHOTO: KIMBELL ART MUSEUM/ART RESOURCE, NY.

of whether these antique "feminine" qualities are still extant in works of art is not really an issue here. Of course they are, although they are no longer acknowledged by our language of value. As such they remain *verbally invisible* and therefore accidental to any determination we might make in "serious" discourse about the virtues of the work. This condition contributes mightily to the disingenuous relationship between criticism and the marketplace. There can, in fact, be no resolution between a language of criticism devoted to principles of abstract speculation and a market that functions by virtue of perceived relationships between human beings and works of art. Second, the question of whether these two sets of traditional attributes are really masculine or feminine is beside the point as well. Even if it's true (as it seems to me to be) that these traditional antinomies have more to do with our changing conceptions of power and entitlement than with any so-called fact of biological gender, traditional fictions of gender inform traditional behavior, and not just my revisionist concept of it.

So, for me at least, the consideration of the gender of works of art raises a complex of aesthetic and moral issues that I would hint at by describing a part of a walk through the Kimbell Art Museum in Fort Worth, Texas. Principally, I am interested in the radical change of moral climate one experiences in walking from the room of sixteenth-century pictures into the room of seventeenth-century pictures. One leaves a room hung with, among other things, Bellini's *Christ Blessing* and Titian's *Madonna and Child with Saint Catherine*, and enters a room hung with Caravag-

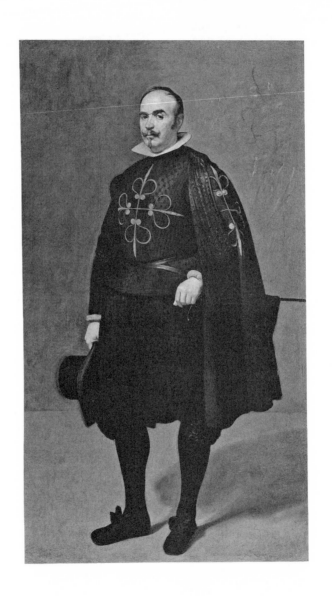

gio's *The Cardsharps*, La Tour's *Cheat with the Ace of Clubs*, Murillo's *Four Figures on a Step*, an El Greco cleric, a Velázquez soldier, and Ribera's *Saint Matthew*.

The first thing you notice as you pass into the seventeenth century is the rotation of the picture plane. The sixteenth-century window into the picture spins upon its axis to become the seventeenth-century window looking out. Recession is replaced by foreshortening, "feminine" space by "masculine" intrusion. The Renaissance invitation to step out of the real, through the picture plane into the possibility of ideal mercy, is replaced by the Baroque intrusion of secular power—by images whose icy naturalism demands to be perceived as *more real*, more authoritative, than the reality in which you stand. Your role as the viewer is radically altered: in the sixteenth-century room you were the *beholder* —the welcomed guest invited by Christ and the Madonna into the remote, Arcadian *potta del cielo* receding beyond them. Upon entering the seventeenth century, you became the *beheld*—held in place outside the space of the paintings by the authority of glance and illusion. You stand in the dock before the elevated figures of Ribera's saint, El Greco's cleric, and Velázquez's soldier, all of whom stare ruthlessly

down upon you. Beyond them, there is no mysterious appeal, no refuge or respite, only darkness.

Even the genre pictures in the seventeenth-century room insist upon your original sin, your guilt and complicity. The space of Caravaggio's *Cardsharps* extends into the room where you stand; it makes you an intimate witness and an accessory to a deception that you can do nothing about. The same is true of La Tour's *Cheat with the Ace of Clubs,* with the additional fillip that the cheat is glancing out of the picture plane, nailing you in your complicity. In Murillo's *Four Figures on a Step,* the entire picture pivots upon the implied intentions of the viewer, who stands, in effect, in the street gazing at a pimp, his whore, and an old woman presenting the backside of her child to the viewer in an obvious tableau of procurement. The viewer is forced into the role of lascivious purchaser, locked in place by the complex invitations in the gazes of the man and the two women.

What interests me in the radical climatic shift between these two rooms of splendid pictures is that the shift of formal gender from "feminine" to "masculine" space is accompanied by a congruent shift of gender-related moral concerns, as described by Carol Gilligan in her books *In Another Voice* and *Mapping the Moral Domain.* Early in her career as a psychologist, Gilligan realized that most psychological research into the nature of human value judgments had been conducted with male subjects. Over the next decade, she and her colleagues worked to

redress this imbalance. In the process they discovered that men and women in our culture, at that time, addressed moral issues from distinctively different perspectives. Men tended to make assessments based on what Gilligan calls the morality of "judgment," derived from abstract ideas of justice based on a hierarchy of values and responsibilities aimed at preserving the separation and radical autonomy of the individuals involved. Women, on the other hand, even when they arrived at the same conclusions, tended to base their decisions on what she calls the morality of "care," derived from a vision of human interdependence, human need, shared values, communication, and the possibility of nurture.

Before the ink was dry on Gilligan's pages, of course, men and women stopped aligning themselves with the moralities she had assigned to them. Gilligan's description of the morality of judgment, however, does provide a fairly accurate model for the canon of most twentieth-century art in its hierarchical emphasis on autonomous noncommunication. Moreover, Gilligan's distinction between the morality of care and the morality of judgment almost exactly describes the change of climate between the sixteenth- and seventeenth-century rooms in the Kimbell Art Museum. Neither have anything to do with actual sex or gender, of course, and everything to do with power and with the relative cultural esteem in which we hold passivity and aggression. Moreover, the elegant shift in the antique moral climate of painting between the sixteenth century and

the seventeenth should remind us of the extent to which the ideologies of care and autonomy now manifest themselves as care *for* autonomy. In a malignant folie à deux, toxic "feminine" care is extravagantly expended upon toxic "masculine" autonomy. The culture has made an industry of swaddling unyielding and ungenerous artifacts in the garments of crippling professional nurture. As a result, even the power that these modern objects acquired by dispensing with generosity is neutralized by the tenderness with which they are held in custodial restraint. Finally, I should note that neither Baroque intrusion nor Renaissance recession can be persuasively approximated by a photograph.

The "death of modern painting" signifies a rebellion against these gendered assumptions, always keeping in mind that modern paintings themselves are merely objects and not particularly beholden to the assumptions we bring to them. Even so, painting was abandoned for other less arduous and less subtle genres. These perform the tasks that premodern painting performs with so much more precision and acuity. The pivot of my complaint may well be that most "new genres" seem to be blunt instruments when it comes to moral and spatial nuance. In any case, if you place Velázquez's soldier and Bellini's Christ face-to-face, you have the entire dialectic visualized: the necessity of judgment facing the possibility of mercy, the elegance of autonomy facing the generosity of beauty, the hard foreground of controllable fact facing the mystery that dissolves into the

distance. Somewhere between them, I insist, lies a richer reality, a better language, a more complex sense of community, and more courageous art. Something more than the inarticulate, intransitive flatland of the modern picture plane faced off against revisionist squadrons of Cibachrome saints, motley performers, and videotapes of mimes in the fog.

After the Great Tsunami: On Beauty and the Therapeutic Institution

The judicial distinction between contract and in-
stitution is well known: the contract presupposes
in principle the free consent of the contracting
parties and determines between them a system
of reciprocal rights and duties; it cannot affect a
third party and is valid for a limited period. Insti-
tutions, by contrast, determine a long-term state
of affairs which is both involuntary and inalien-
able; ... it tends to replace a system of rights and
duties by a dynamic model of action, authority
and power.

Gilles Deleuze, "Coldness & Cruelty"

The subject here is "beauty"—not what it is but what it does—its rhetorical function in our discourse with images. Secondarily, the subject is how, in the final two-thirds of the twentieth century, we came to do without it, and how we have *done* without it by reassigning its traditional function to a loose confederation of museums, universities, bureaus, foundations, publications, and endowments. I characterize this cloud of bureaucracies generally as the "therapeutic institution," although other names might do. One might call it an "academy," I suppose, except for the fact that it upholds no standards and proposes no secular agenda beyond its own soothing assurance that the "experience of art," under its politically correct auspices, will be redemptive—an assurance founded upon an even deeper faith in "art-watching" as a form of grace that, by its very nature, is good for both our spiritual health and our personal growth—regardless and in spite of the crazy shit that individual works might egregiously recommend.

It goes without saying that this therapeutic institution is a peculiarly twentieth-century artifact. To understand just *how* peculiar, we must ask ourselves: What other century since the Dark Ages could invent an institution whose mandate is to kidnap an entire province of ongoing artistic endeavor from its purportedly dysfunctional parent culture—with the purported intention of "rescuing" that endeavor from the political, intellectual, and mercantile dynamics that produced it? None, I would suggest, but after centuries of bureaucrats employing images to validate, essentialize, and detoxify institutions, to glorify their battles, celebrate their kings, and publicize their doctrines—we now have an institution to validate, essentialize, and detoxify our *images*—to glorify art's battles, celebrate art's kings, and publicize art's doctrines—and, of course, to neutralize art's power. It should come as no surprise that this therapeutic institution came into being in the aftermath of the greatest flowering of unruly images in the history of man, at the conclusion of the longest sustained period since the Renaissance during which institutional and pedagogical control over the arts was nominal at best.

A gorgeous island of gaudy, speculative images was borne forth like blossoms on the great tsunami of doubt and spiritual confusion that swept through the late nineteenth century, cresting into the twentieth and exploding across Europe in a conflagration of wars and revolutions, scattering beauty among the bodies. By the 1920s, however, answers were once more

available, assurances against doubt and confusion were at hand, and there were men in power to assure our compliance with these assurances. Quite sensibly, these new ideological elites reasserted control. In the Soviet Union, Stalin's cultural commissars legislated the absolute subordination of form to content in the name of the proletariat. In the United States, Alfred Barr, in the service of inherited capital, proclaimed the absolute subordination of content to form. In Germany, in the name of the Nazi bourgeoisie, Reichsminister Joseph Goebbels, the brightest and wickedest of them all, orchestrated their perfect match. Different agendas? Maybe, but each of these three putsches, almost simultaneously, consolidated and activated the powers of patronage to neutralize the rhetorical power of contemporary images—to minimize the slippage between how it looks and what it means—because as long as nothing but "the beautiful" is rendered "beautifully," there is no friction, no subversive pleasure, and things do not change.

The preemptive Fascist appropriation of Futurist rhetoric in Italy was a different political animal, although it speaks to the same slippery issue of private rhetoric and public power. As it turned out, Mussolini's coup would not meet its match until the early 1960s when Ivy League cold warriors in Washington coöpted the cultural chauvinism of Abstract Expressionism by mounting touring exhibitions that effectively converted Pollock's canvases into muscular, metaphoric billboards for a virile, imperial, "all-over" America.

Today, the rhetorical nature of the discourse is hardly debatable. The contemporary axiom that the meaning of a sign is the response to it requires that art be regarded as a collection of aesthetic propositions, as rhetorical instrumentalities rather than philosophical entities or essential copies. Further, in a legalistic culture like our own—in which the status of the image has been problematic since Moses came down the mountain, and all great visual artifacts, from the Sistine Chapel to Pollock's *Blue Poles*, are occasions for disputation and not consensus—a certain inverse variability between how it looks and what it means is taken for granted. Under the waning aegis of the therapeutic institution, however, the consequences of this slippage remain unexamined.

Freud puts his finger on this disjunction in his essay "Creative Writers and Daydreaming." Here, Freud characterizes the artist's task as the covert fulfillment of socially unacceptable infantile wishes in which we acquiesce on account of

> the purely formal—that is, the aesthetic—yield of pleasure which he [the artist] offers us in the presentation of his phantasies. We give the name of *incentive bonus*, or *fore-pleasure*, to a yield of pleasure such as this, which is offered to us so as to make possible the release of still greater pleasure arising from deeper psychical sources.

By characterizing our "formal" pleasure as "pure," Freud

presumes that the formal aspects of a work's presentation are somehow distinguishable from its more radical content and, further, that they somehow mitigate it. I think Freud is wrong, that far from ameliorating the artist's radical, infantile wishes, the rhetoric of beauty *politicizes* them, makes them publicly available, and proposes them, like it or not, as social options. Further, I think Goebbels understood this, as did Alfred Barr, as did Stalin—and that none of them were particularly sanguine at the prospect.

This is not to say that art is just advertising, only that art, outside the institutional vitrine of therapeutic mystery, is never *not* advertising and never apolitical. Commodity advertising and pornography define the limiting conditions of art's project, its instrumental and somatic extremes, but they participate, just like the real thing, in that shifting, protean collection of tropes and figures that comprise "the rhetoric of beauty." In fact, since advertising and pornography exist outside the purchase of the therapeutic institution, they continue to employ that powerful rhetoric to sell soap and insinuate sexual responses. They create images in which the figures of beauty function as they always have in Western culture. First, they empower the beholder to respond by exhibiting markers that designate a territory of shared values. Second, they valorize the content of the image, which, presuming its litigious or neurotic intent—Goebbels notwithstanding—is always in need of valorization.

The unfashionable implication of this characterization is that

RAPHAEL *Madonna of the Chair* (Madonna della seggiola).
GALLERIA PALATINA, PALAZZO PITTI, FLORENCE.
PHOTO: SCALA/ART RESOURCE, NY.

rhetorical beauty, as we are considering it, is largely a *quantitative* concept. It proposes to enfranchise *numbers of individuals* with varying quantities of incentive or excitement. Since this rhetoric can on occasion perform one of its functions more efficiently than the other, we may poll for the "most beautiful image," the one that enfranchises the most people—probably the *Mona Lisa*, regardless of what I think. We may also speculate on "the most *effective* beautiful image," the image that valorizes the most preposterous content to the most people for the longest time. Raphael's *Madonna of the Chair* is a contender here, having exquisitely valorized the iffy doctrines of the incarnate word and the virgin birth to generations of Catholics worldwide, all of whom should have known better.

Further, we might seek out the "most *efficient* beautiful image" that valorizes the most egregious content to the wealthiest and most influential beholders exclusively. In this category, I think we must acknowledge Picasso's *Les demoiselles d'Avignon*—either as a magnificent "formal breakthrough" (whatever that is) or, more realistically, as a manifestation of Picasso's dazzling insight into the shifting values of his target market. So consider this scenario: Pablo comes to Paris, for all intents and purposes a bumpkin, with a provincial and profoundly nineteenth-century concept of the cultural elite and its proclivities—imagining that the rich and silly still prefer to celebrate their privilege and indolence by "aestheticizing" their surroundings into a fine-tuned, fibrillating *atmosphere*. He proceeds to paint his Blue and Rose period pictures

under this misapprehension (pastel clowns, indeed!)—then Leo and Gertrude introduce him to a faster crowd.

He meets some rich and careless Americans and gradually, being no dummy, perceives among the cultural elite with whom he is hanging out, and perilously hanging on, a phase-shift in their parameters of self-definition. These folks are no longer building gazebos and placing *symboliste* Madonnas in fern-choked grottos. They are running with the bulls—something Pablo can understand. They are measuring their power and security by their ability to tolerate high-velocity temporal change, high levels of symbolic distortion, and maximum psychic discontinuity. They are *Americans*, in other words, post-Jamesian Americans in search of no symbolic repose, unbeguiled by haystacks, glowing peasants, or Ladies of Shallot. So Pablo Picasso—neither the first nor the last artist whom rapacious careerism will endow with acute cultural sensitivity—goes for the throat, encapsulates an age with a painting of French whores, and, through no fault of his own, creates the cornerstone of the first great therapeutic institution.

I have no wish to diminish Picasso's achievement by this insouciant characterization of it, but I do want to emphasize the fact that, during the period in which *Les demoiselles* was painted, pictures were made primarily *for* people, not against them—and to suggest further that if we examine the multiplication of styles from roughly 1850 to 1920, we will find, for each one of them, a coterie of beholders, an audience already in place. Thus, a veritable bouquet of styles, of "beauties," was invented, *and none of*

them died, nor have they since. An audience persists for each of them, and if I seem to have splintered the idea of beauty out of existence by projecting it into this proliferation, well, that is more or less my point.

For nearly seventy years, throughout the adolescence of what we call high modernism, professors, curators, and academicians could only wring their hands and weep at the spectacle of an exploding culture in the sway of painters, dealers, critics, shopkeepers, second sons, Russian epicures, Spanish parvenus, and American expatriates. Jews abounded, as did homosexuals, bisexuals, Bolsheviks, and women in sensible shoes. Vulgar people in manufacture and trade who knew naught but hard money and real estate bought sticky Impressionist landscapes and swooning Pre-Raphaelite bimbos from guys with monocles, who, in their spare time, were shipping the treasures of European civilization across the Atlantic to railroad barons. And most disturbingly, for those who felt they ought to be in control—or that *someone* should be—beauties proliferated, each finding an audience, each bearing its own little rhetorical load of psycho-political permission.

It is no wonder, then, that the cultural elites in Europe and America would take the occasion of the Great Depression—while those vulgar folks in trade were so ignominiously starving—to reassert their control over a secular culture run rampant. They did so blandly in Paris and Bloomsbury, violently in Moscow and Berlin, and ever so elegantly in New York, where a brilliant young gentleman managed to parlay his tandem passions for contemplat-

ing little brown pictures and dining with rich old women into a *Museum* of Modern Art. It was a historic moment, a watershed, to say the least, so it is not surprising, perhaps, that a great deal of the art that Alfred H. Barr Jr. appropriated from the rich was simultaneously being denounced by *Reichsminister für Volksaufklarung und Propaganda* Joseph Goebbels as inappropriate for the *volk* (a fact that should pique our suspicion as to whether Barr's institutionalization of this work doesn't betray his own reservations about the appropriateness of these images, in unredeemed condition, for the *volk*). At any rate, Barr and Goebbels, having acquired institutional power, proceeded with roughly parallel agendas—both of them clearly operating out of an understanding that works of art, left to their own audiences, have the potential to destabilize the status quo.

Barr, operating from the premise that art can be good for us, selected the art that he deemed best for us and emphasized, by text and juxtaposition, those aspects of the works that he thought signified their quality. Thus, if one had attended his museum's opening exhibition of works by Cézanne, Gauguin, Seurat, and van Gogh, it would have been clear that Barr was reconfiguring their rhetorical aspects into "formal values," recommending these four artists to us for their rather narrow area of regional and technical convergence, while suppressing their evident and candidly disparate social, political, and philosophical agendas.

Goebbels, on the other hand, selected the art that he considered worst for us for the exhibition *Entartete Kunst*. He then empha-

sized, by text and juxtaposition, those attributes that he thought signified their degeneracy. These turned out to be many of the same attributes that Barr thought signified their quality, but not to worry: One curator objectifies the rhetorical aspects of the art, another vilifies them—as long as institutional control is reasserted and the rhetorical aspects of beauty are neutralized, what's the difference? Either way, our relationship to images authorized by beauty is distinct from our relationship to images authorized by the government, and radically so. This is no less the case when a single work undergoes a shift of authorization. Anyone who has loaned work to a museum exhibition can tell you that the work in the museum is something other than the work in one's home. Visiting the exhibition can feel like visiting an old friend in jail. The work hangs there among a population of kindred offenders, bereft of its eccentricity, yet somehow, on account of that loss, newly invested with a faintly ominous kind of parochial power. To suggest the nature of this distinction, I would like to draw some analogies between these relationships and those discussed by Gilles Deleuze in his 1967 essay "Coldness and Cruelty."

In this essay, Deleuze seeks to unpack the portmanteau concept of sadomasochism and dissolve the presumed reciprocity that Freud infers between sadism and masochism. If one is willing to accept Sade and Masoch as exemplars of the idioms that bear their names, he does so quite successfully, returning to their texts and elegantly delineating their contrasting content. Most crucially, Deleuze argues that, although both Sade and

Masoch portray persecutors and victims, dominants and sub-missives, and both exploit the sexual nexus of pleasure and pain, there is no reason to contrapose them. Similar narratives do not necessarily tell similar stories, nor even versions of the same story. In narratives of desire, it matters *whose* story it is, who writes the script and who describes the scene—who determines whose fate and who controls the outcome. When these factors are taken into account, the dramas of Sade and Masoch diverge into different dimensions, generating distinct and profoundly dissonant environments.

Masoch tells the victim's story, and only his. In Masoch, it is the *victim* who recruits the cast, describes the scene, and scripts the action. And ultimately, by negotiating the conditions of his own servitude and "educating" his persecutor, Masoch's victim dominates the scene of his submission and derives from it a yield of pleasure. In this sense, the parallel narratives of masochism and representative democracy tell similar stories. As citizens of a republic, we too select our masters, determine the ground rules of our subjugation, and set the limits of our trust. Sade, on the other hand, tells the master's story, always, and *his* script is presumed to have the philosophical force of reason, the authority of nature. Sade's autocrats ruthlessly impose the logic of their natural philosophy upon unwilling victims, alternately "instructing" them in its rigor and scientifically describing for us its technical application.

The mechanisms of these two narratives diverge at every

point. The sadist has no insight into masochism, nor any need of masochists. He requires an unwilling victim whom he can degrade and instruct. Likewise, the masochist has no need, nor any understanding, of the sadist. He requires a willing mistress whom he can elevate and educate. Sadism is about the autonomous act. (Sade narrates actions.) Masochism is about theatrical suspense. (Masoch "freezes the scene.") Sadism is about nature and power. Masochism is about culture and, ironically, the nature of contract law. Finally, sadism deals with the imposition of formal values and the cruel affirmation of "natural law," whereas masochism focuses on deferred sublimity and the vertiginous rhetoric of trust. As a consequence, Deleuze notes, "the sadist is in need of institutions" and "the masochist of contractual relations."

The analogy I wish to draw here is blatant. The rhetoric of beauty tells the story of those beholders who, like Masoch's victim, contract their own submission—having established, by free consent, a reciprocal, contractual alliance with the image. The signature of this contract, of course, is beauty. On the one hand, its rhetoric enfranchises the beholder; on the other hand, it seductively proposes a content that is, hopefully, outrageous and possible. In any case, this vertiginous bond of trust between the image and the beholder is private, voluntary, and a little scary. And, since the experience is not presumed to be an end in itself, it might, ultimately, have some consequence beyond the encounter.

The experience of art within the therapeutic institution, by contrast, *is* presumed to be an end in itself. Under its auspices, we play a minor role in the master's narrative—the artist's tale—and celebrate his autonomous acts even as we are offhandedly victimized by the work's philosophical power and ruthless authority. Like princes within the domain of the institution, or jailhouse mafiosi, such works have no need of effeminate appeal. And we, poor beholders, like the silly *demimondaines* in Sade's *Philosophy of the Bedroom*, are presumed to have wandered in, looking for a kiss. So *Pow!* Whatever we get, we deserve—and what we get most prominently is ignored, disenfranchised, and instructed. Then we are told that it is "good" for us.

Thus has the traditional, contractual alliance between the image and its beholder (of which beauty is the signature, and in which there is no presumption of received virtue) been supplanted by a hierarchical one between art, presumed virtuous, and a beholder presumed to be in need of it. This is the signature of the therapeutic institution. And although such an institution, as Barr conceived it, is scarcely imaginable under present conditions, it persists and even flourishes—usually in its original form but occasionally under the administration of right-thinking creatures who presume to have cleansed its instrumentality with the heat of their own righteous anger and to use its authority (as the Incredible Hulk used to say) as a "force of good."

This is comic-book thinking for bureaucrats. In fact, nothing redeems but beauty, its generous permission, its gorgeous celebra-

tion of all that has previously been uncelebrated. If we entertain, even for a moment, the slightest presumption that an institution, suddenly and demonstrably bereft of its social and philosophical underpinnings, is liable to imminent collapse, we have committed what George Bernard Shaw considered the most suicidal error that a citizen can. As Shaw pointed out, institutions die from loss of funding, not lack of meaning. *We* die from lack of meaning and of joy.

American Beauty

"Beautiful!"

Assorted Americans

1 The Exclamation

I began writing the essays that precede this one twenty years ago when I was living at the beach in San Diego, comfortable in my tiny niche. Until the panel discussion that I describe in "Enter the Dragon," I had never uttered the word "beauty" in public. Once I had, my life became a lot less pleasant. Many powerful and influential people, I discovered, thought art and art criticism would be substantially democratized if we could but cloak with forgetfulness those eidetic encounters with beauty that are virtually defined by the ease and pleasure with which we remember them. In the preceding essays, I try to defend my predisposition to speculate on beauty. In this essay I sketch out the democratic tradition of doing so. The fate of beauty itself, besieged by zealots, has never been my concern. Beauty is and always will be blue skies and open highway.

I would like to begin by talking about the way contemporary

Americans talk about the things they find beautiful—whenever and wherever they find them—because they talk about them all the time. When they do, they use the word "beautiful" with consistency and precision in a very traditional way that dates back to the Renaissance and beyond that to Latin antiquity. In this vernacular usage, the word "beautiful" bears no metaphysical burden. It signifies the pleasure we take in something that transcends the appropriate. It identifies that "something" as better, somehow, on account of its beauty. In everyday talk, the word usually occurs as an exclamation. "Beautiful!" we say, using the word as a demonstrative gesture to locate the source of our involuntary pleasure in the external world. More often than not, these exclamations are followed by talk—by comparisons, advocacy, analysis, and dissent.

The object we identify as beautiful may be anything from a chemical sunset to a rookie's jump shot. The mystery resides in our precognitive certainty that there are sunsets and jump shots worthy of mention. Otherwise why utter the word "beautiful" at all? And why respond when someone else does? The pleasure that our exclamation acknowledges is involuntary, private, and self-fulfilling. Why make it public? For three reasons, I think. First, we speak the word "beautiful" and respond to its being spoken because we are good democrats. We aspire to transparency and consensus. Second, we speak the word "beauty" and respond to its being spoken because we are citizens of a self-consciously historical society. We count these personal responses as votes for the way things should look or sound;

we acknowledge the chance that, once made transparent, these spontaneous exclamations may presage a new consensus. Third, we speak the word and respond to it because we can, because we live in a society in which freedom of speech and the pursuit of happiness are officially sanctioned.

So we talk, because the experience of American beauty is inextricable from its optimal social consequence: our membership in a happy coalition of citizens who agree on what is beautiful, valuable, and just. In this we are the direct descendants of those Renaissance artists, mercantile princes, and connoisseur churchmen who spoke of beauty the way we do. Those sixteenth-century Italians, in their retrospective reverence for Pliny and Cicero, rejuvenated the antique artistic discourse of the *paragone*—the argumentative comparison, competition, and ranking of things, like to like. Under the auspices of the *paragone*, devotees of the "new learning" sought to establish objective standards by isolating undeniable paragons of virtue. They considered and reconsidered, in taxonomic hierarchy, the relation between one design and another, one painting and another, one artist and another, one genre and another, and one art and another.

These speculations established not one objective standard. In fact, they inadvertently facilitated a permanent and profoundly democratic revolution in the way we look at things in the West. Before the reestablishment of the *paragone,* the proper way of looking at an image was to "read through" it—to tease from its illusory depths an interpretation of the events that the image had been

commissioned to portray The *paragone* instead compares paintings to paintings, foregrounding their physical and abstract attributes. Looking and appraising in this way, like to like, reduces paintings' official content to competitive categories (Best Annunciation, Best Flight into Egypt, Best Crucifixion).

Authorized instruments of sacred devotion and political power are thus transformed into objects of private delectation. One's preference for Raphael's *Annunciation* over Guido Reni's as a paragon of virtue asserts the contour of one's own values relative to those of Raphael and Reni and the Roman church. For the sake of an argument, the clarity and repose of Raphael's painting may be freely elected to represent some aspect of one's personal taste. This requires hubris, and the vanity of enthusiasts who appropriate devotional objects as icons of self-representation has been much decried down through the centuries. It has never lost its status as the primary vice of connoisseurship. Even so, with the rebirth of the *paragone*, the power to invest works of art with meaning and value begins to shift from the supply side to the consumer side of the visual transaction.

Since that time, our propensity to squabble about the relative beauty of things has become inextricably entangled in the folkways of the mercantile republics in which these squabbles first flourished. They are equally indebted to the conventions of republican democracy, to the dynamics of commerce, and to our residual pagan penchant for investing objects with power. The give-and-take through which we ascertain the relative value of

objects derives from the haggle of the marketplace. There is no other precedent. At the same time, even though there is always a hard market in objects at the spine of our arguments about beauty, most of the buying and selling is verbal and symbolic, something closer to a civic forum in which objects (often in the possession of others) are elected by free-floating constituencies of citizens as incarnations of their shared pleasures and desires.

The mystery of the art market is that some people would rather possess an object of marginal utility than the ultra-usable money they exchange for it. This is the mystery of all markets in which taste is transformed into appetite by a nonpecuniary cloud of discourse that surrounds the negotiation. There is always a tipping point at which one's taste for Picasso or freedom or pinot noir becomes a necessity, or at least something one would rather not do without. The exact nature of this "something" is effervescent and indistinct. Moreover, since the value of art objects is purely extrinsic, invested from without, our adjudications are always tossed in the tides of personal and social evaluations. When exchange value segues into social value, commercial haggling segues into ethical speculation. Any intrinsic qualities the object might possess are quickly subordinated to the object's personal and cultural meaning for the human beings who are bargaining over it.

In practice, these arguments address a perceived inequity between a ballpark price and an ineffable, unarticulated value that tends to remain out of sight, open to speculation and unavail-

able to consciousness. It is a world of semblance. Something seems too cheap to someone; it seems too expensive to another; to a third, it seems correctly priced. So we haggle about everything, from the bouquet of wine to the ambience of cities. The sum of our own positions on things we value determines the shape and texture of our social lives. This is why contemporary Americans acknowledge the things they find beautiful and talk about them all the time. Our commonality as citizens resides almost exclusively in the world before our eyes. Those little explosions of harmony with the world beyond us constitute landmarks in our inner lives. The landmarks we share with others have personal importance to us as opportunities to experience the confluence of our commonality.

As Americans, we are citizens of a large, secular, commercial democracy; we are relentlessly borne forth on the flux of historical change, routinely flung laterally by the exigencies of dreams and commerce. We are bereft of the internalized commonalties of race, culture, language, region, and religion that traditionally define "peoples." As such, we are social creatures charged with inventing the conditions of our own sociability out of the fragile resource of our private pleasures and secret desires. So, lacking the terms for communication, we *correlate*. We gather around icons from the worlds of fashion, sports, the arts, and entertainment as we would about a hearth. We trace infinite lines of transit around these strange attractors. We organize ourselves in nonexclusive communities of desire. We stay or go according to the whims of romance

or the climate of the times. This "weather map" model of social organization may be construed as beguiling or appalling, but there is no denying its efficacy, its appropriateness, or its provenance.

2 The Pursuit of Happiness

We hold these truths to be self-evident, that all men are created equal, that they are endowed by their Creator with certain unalienable Rights, that among these are Life, Liberty and the pursuit of Happiness.– That to secure these rights, Governments are instituted among Men, deriving their just powers from the consent of the governed,– That whenever any Form of Government becomes destructive of these ends, it is the Right of the People to alter or to abolish it, and to institute new Government, laying its foundation on such principles, and organizing its powers in such form, as to them shall seem most likely to effect their Safety and Happiness.

Declaration of Independence, July 4, 1776

The second sentence of the Declaration of Independence is not a particularly beautiful sentence, but the idea of American beauty could not exist without the cool impudence of its first seven words: *We hold these truths to be self-evident.* In a single breath, this phrase exempts the sentence's subsequent asseverations of human equality and unalienable rights from the claims of traditional conduct, religious belief, metaphysical certainty, and scientific proof. The words do what the thirteen colonies were themselves doing. They declare their independence and divest themselves of all external authority. They do not say, "These things are true,"

or "These things have always been true," or "These propositions have been proved to be true," or "These truths, validated by scripture . . ." They don't even say, "These truths are self-evident." They say that the Second Continental Congress *holds* the subsequently enumerated Truths to be self-evident, on its own authority, and henceforth, within the purview of congressional authority, they shall have the status of law. Period.

There is no confirming rationale, only the imperative challenge to hold these principles in perpetuity. Equality and unalienable rights are bestowed by the authority of the Second Continental Congress, whose authority derives from the consent of the Governed, who derive their rights from the fiat of the Declaration's opening clause: the Congress empowers the people to empower the Congress to empower the people. Upon this *donee*, this self-contained legal asseveration, clenched tight as a fist, was the United States founded. With this concise, circular assertion of forms and principles the Congress proposes to guarantee, with qualifications, certain rights to its citizens. There is no existential quibbling. Equality is posited whether it exists or not. Life is guaranteed under the rubric of Safety. Happiness (whether *it* exists or not) is not assured, but its pursuit is protected.

This final permission, to pursue happiness with no promise of getting it, has always been the most beguiling to me. By distinguishing safety from the pursuit of happiness and promising both, the language of the Declaration introduces dynamic instability into the philosophy of public governance. Liberty is defined both

positively and negatively: the government will act to ensure our safety, and it will stand back as we act on our own behalf in the "pursuit of happiness." When that pursuit putatively threatens our safety, however, the government invariably steps in. Safety trumps happiness, the government always wins, and beauty is always a casualty. This phrase, "the pursuit of happiness," is generally presumed to be a Lockean euphemism that guarantees the pursuit of commerce and industry under the purview of contract law. It certainly is that; it is also true that, beyond the prerogatives of contract law, we have no civil rights to speak of. But the phrase is not dead language. It invests the neglected discipline of eudaemonics with legal consequence. It derives from a rhetoric in which commerce and industry are said to produce and disseminate "goods"—lowercase virtues incarnate. Uppercase Happiness, in the locution of the Second Continental Congress, is the Good toward which all these lowercase goods aspire.

Moreover, the goods that are legally enfranchised by the right to pursue happiness (reinforced by the Constitution and Bill of Rights) extend well beyond objects of use and consumption to include intellectual and artistic properties. Since we are each free to pursue our own happiness, the relative value of all these "goods"— beans, true love, biscuits, or paintings—may be, and should be, determined independent of governmental edict, regardless of scientific proof, and, whenever necessary, contrary to religious or metaphysical certainty. These propositions are adjudicated in discourses of the forum, the court, the piazza, and the marketplace.

Herein lie the cosmopolitan pagan roots of the republic. So it is not surprising that a society whose citizens propose and elect a hierarchy of incarnate creatures to represent their interests in the realm of governance should propose and elect a hierarchy of incarnate goods to represent their transient and variegated longings. It is hardly imaginable, in fact, that citizens of a society like this, for whom the pursuit of happiness is a primal mandate, would *not* produce grails to embody the apotheosis of their quest. It is inconceivable that icons of happiness and desire would *not* proliferate in the tides and currents of this fluid cultural weather system.

Every morning, when I was in the sixth grade at Santa Monica Elementary, we stood beside our desks, stared at the flag, and, under the baton of Ms. Veronica Chavez, sang "America the Beautiful." La Chavez sang the official line: *Oh beautiful for spacious skies, for amber waves of grain . . .* We sang our own countertext, a paean to beauty in its presence: *Oh beautiful for gracious thighs, for amber babes of Spain . . .* It was a puerile encomium, but I have not forgotten the pride we took in our collective poiesis as we sang out, *Veronica, Veronica, God shed his gaze on thee . . .* And I have yet to discover a contemporary whose class bards did not invent their own customized lyrics to be sung to this tune—none as euphonious as ours, of course. In any case (probably thanks to the Second Continental Congress), we all felt deserving of our own aesthetic. We could agree on "Oh beautiful for" but would complete the sentence, in meter, to taste. Each of us asserted our own brand of beauty as a privilege of citizenship, as an icon of happiness, and we intended to pursue it.

Responding to our youthful expectations, the city of Santa Monica presented us with beautiful things at every turn, and with many things that were not beautiful. At recess, milling around in the asphalt schoolyard, we beach dudes extolled the sublimity of roaring, smoking surf, the romance of fuzzy palm trees in the fog; and we deplored the grungy indignity of city buses. Fledgling Bukowskis among us took exception to our antiurban cant, as did the barrio kids for whom nothing that was not an automobile, a pop tune, or Veronica Chavez qualified for serious contemplation. So the argument would bubble along—the song holding us together, the lyrics setting us apart. In this haphazard manner, the vernacular discourse of beauty flourished at Santa Monica Elementary. Not one of us would have quarreled with Baudelaire's dictum in *Le Salon de 1846* that "there are as many kinds of beauty as there are habitual ways of seeking happiness."

Nor would any of us have quarreled with Baudelaire's assertion that we seek happiness as a matter of course and call it beauty. If we take the view from the terrace, it's hard to deny the fact that all of us, in the conduct of our daily lives, pursue beauty, happiness, and justice (conceived as beauty and happiness free of impediment). We brave crowds to gaze at paintings on the walls of museums. We gather on scenic overlooks just off the interstate. We cheer as the jump shot swishes or the skater lands smoothly. We sit attentive as the solo or the aria concludes, and occasionally, in our delight, we mutter this involuntary vocalization: "Beautiful!" Or sometimes, "Great!" Or, if we reside in the borough of

Queens, "Gorgeous!" Then we look around for confirmation or argument. Either will do, since the only qualification for arguing about beauty is a shared experience, and we share a lot.

Mass production, mass communication, and sheer mobility make available to us a vast repertoire of replicable objects and events. Having these things in common, and little else, we talk about them obsessively. Sometimes we learn from these conversations, but knowledge is not the point. There are no correct interpretations. We may, and routinely do, misinterpret the putative content of the things we find beautiful. And we lobby for our misinterpretations—as every gay guy in my high school class enthusiastically misinterpreted episodes of *The Flying Nun*, and the Lesbian Coalition of Detroit endorsed the rock machismo of MC5 and the Detroit Wheels in the interest of its own butch agenda. We talk about beauty with anyone, anyplace and anytime, because we know it when we see it, and we remember it—since the absence of beauty informs our recognition of the banal and the grotesque, the existence of which few have the temerity to question.

John Ashbery once remarked that, after we discover that life cannot possibly be one long orgasm, the best we can expect is a pleasant surprise. I think of encounters with beauty in just this sense, as pleasant surprises, positive moments in the history of our free responses to the world. For most human beings, these are far from daily occurrences, but they can be, and they do happen. We encounter the embodiment of what we like, what we are like, and what we want in the external world, and we are delighted. Our

bodies, our minds, and the world beyond us coalesce and vibrate like a tuning fork. This sudden, unexpected harmony of body, mind, and world becomes the occasion for both consolation and anxiety. In that moment, we are at home with ourselves in the incarnate world but no longer in tune with the mass of people who do not respond as we do. We seek out, as a necessity, the constituency of people who *do* respond, if such a constituency exists.

Thus the urgency of our vocalization: "Beautiful!" Thus our willingness to accost strangers with our enthusiasm, to venture among them in search of coconspirators. In this way, beautiful objects reorganize society, sometimes radically. Random things, found to be beautiful, create polyglot constituencies. They represent for those who convene around them both who they are and what they want. You can argue that we are being seduced into this condition of resonance, and maybe we are, but we have the *right* to be seduced. To save us from seduction is to deny us our protected rights as moral actors. Dismissing our enthusiasm as mere fandom misses the point, because, in a free society, the question of what any group of citizens wants is always a matter of political consequence.

The resulting din of aesthetic contention is so ubiquitous that it's easy to take for granted. It's even easier to deplore the daily fret of living in a nation of exquisite connoisseurs (where yuppies spend more time lingering in front of the Starbucks pastry case, deliberating on their choice of muffin, than I do buying a car), but commercial democracies conduct their business in just this clamorous

way—consider the floor of the stock exchange as a microcosm. We live without rules, regulated by choices that are informed by the ongoing murmur of advocacy, discrimination, and dissent about everything from chainsaws to eyeliner, from Giacomo Puccini to Jan Van Eyck. The cornucopia of options is so overwhelming that the bulk of the choices we make are purely speculative, less about acquiring things than the ongoing mystery of pleasant surprises— of physical resonance with a world where our responses matter and our vote counts. The simple act of "liking" something bears with it the inference that we have recognized our "likeness" in the world beyond ourselves—something to our taste, like a muffin.

3 Issues of Representation

The acquisition of my tape recorder really finished whatever emotional life I might have had, but I was glad to see it go. Nothing was ever a problem again, because a problem meant a good tape, and when a problem transforms itself into a good tape it's not a problem anymore. An interesting problem was an interesting tape. Everybody knew that and performed for the tape. You couldn't tell which problems were real and which problems were exaggerated for the tape. Better yet the people telling you the problems couldn't tell anymore if they were having the problems or if they were just performing.

Andy Warhol, *The Philosophy from A to B*

Today, in the *New York Times*, there is an item that speaks directly to the echoing consequences of liking and likeness. David Brooks's column quotes Brett Pelham, professor of psychology

at SUNY Buffalo, who has, by some statistical sleight of hand, ascertained that "people named Dennis and Denise are disproportionately likely to become dentists. People named Lawrence and Laurie are disproportionately likely to become lawyers. People named Louis are disproportionately likely to live in Saint Louis and people named Georgia are disproportionately likely" to reside in the Peach State. The inference we may draw from this is that Michel Foucault was right. Our engagement with the tapestry of superficial resemblance that unfolds before our eyes each day—our happy embrace of moments when we find ourselves "rhyming" with the world—still drives the deep tides of our personal existences. We have inherited the proclivities to like things and to liken them to others, a practice long abjured by "advanced thinkers," from the premodern world. Here is Foucault's overview from *The Order of Things:*

> If language exists it is because below the level of identities and differences, there is the foundation provided by resemblances, repetitions and natural criss-crossings. Resemblance, excluded from knowledge since the seventeenth century, still constitutes the outer edge of language: the ring surrounding the domain of that which can be analyzed, reduced to order and known. Discourse dissipates this murmur [of resemblance] but without it we could not speak.

More specifically, without this murmur, Dennis the dentist,

Laurie the lawyer, Georgia from Georgia, the entire beaux-arts appetite for pleasant surprises, and our multivalent moments of self-recognition would remain inexplicable.

The experience of pleasant surprises, however, is not local to the social experience of commercial democracies. Pleasant surprises are ubiquitous and infinitely variegated. Human beings are each very different and the world so very wide and chock-full of different things that there is never a shortage of occasions for surprise. The conversation arising from pleasant surprises, however, flourishes to best effect in highly mobile, loosely organized, and casually administered commercial societies whose members feel privileged to respond. Better organized and more rigorously administered societies—those that are less practically pagan and restlessly cosmopolitan—cope with pleasant surprises less efficiently. The experience of American beauty, when it surprises us, is always, potentially, an occasion for change—for changing one's beliefs, one's friends, one's fashions, one's furnishings, or one's livelihood—for changing one's home, in the hope of discovering a new home that "feels more like home."

In societies where precipitous change is not an everyday event—in tribes, villages, theocracies, armies, academies, monasteries, laboratories, and governmental bureaucracies—pleasant surprises take on a darker aspect. In these realms, one's eccentric taste is more likely to be construed as a threat to the community, as a symptom of disloyalty, than as an icon of aspiration. In tribal environments, the consequence of espousing a dissenting aesthetic

(as each of us do) is always alienation and anxiety. Any tribal elder will tell you that it was young Paris's pleasant surprise and his cosmopolitan pursuit of happiness that started the Trojan War. It was Helen's *beauty*, nothing other, that launched a thousand ships and stacked the dead like cordwood, and you dare not forget it.

So beauty, in most of the world, still constitutes a threat to the community, an invitation to disloyalty, a cosmetic dissimulation, and an attribute of moral weakness. (The Taliban have yet to buy into the whole "pleasant surprise" thing.) Only in commercial democracies, where one's success depends in large part upon one's predisposition to step up and pet the pretty tiger, is beauty deemed a virtue, and beauty only reigns with the ardent consent of the governed. Both Gilles Deleuze and Leonard Meyer, while addressing different subjects, have noted that our routine consent to be governed by the "difficult beauty" of great music, literature and art has about it an element of romantic masochism—the frisson of petting the tiger—as does the dynamic of democracy itself. We do elect our masters, after all, and these masters must ultimately abide by our wishes.

Authoritarian and fundamentalist personalities need not apply. Those who do not feel free to cede control when it promises delight feel anxious and alienated, especially in a permissive society like this one, in which a majority of our cloistered guardians are charged with the task of denying us one sort of permission or another. Societies require guardians, of course, but their job is not ours. Clerics, bureaucrats, accountants, and academics assess

"real" danger, adjudicate "real" value, uncover "true" meaning, and enforce "correct" interpretations. They labor to protect us from error and danger, so we must forgive their distress at the tumult in the street, where everyone, from the deli guy on the corner to the drifter he's hassling, is a brazen, chattering aesthete sporting impudent opinions in lieu of a green carnation. Guardians are concerned with securing our Safety. We are pursuing our Happiness.

In the United States, there is no easy fix for this. More hierarchal European societies have cultural elites, civil servants professionally dedicated to "refining" the taste of the masses—to performing *Coriolanus* for surfers and skateboarders, to bestowing those glittering prizes that encourage intellectual compliance and redirect aberrations in style. The pursuit of happiness in America, by contrast, is a creature of private-sector improvisation. It disdains the tedium of helmet laws, no smoking signs, play dates, and child monitors. It acknowledges our passionate expectation of feeling simultaneously at home in our bodies, in the world, and in society. This sort of civil imperative is only imaginable in a society whose primal texts assert the priority of eudaemonics— where we expect first-rate representation from senators, congressmen, lawyers, paintings, landscapes, pop tunes, cell phones, video cameras, and tape recorders.

In this milieu, the proverbial "issues of representation" are less concerned with how the signifier represents the signified (or fails to) than with how well the beholder and that which is beheld represent one another. In his *Philosophy* Andy Warhol argues that, by

being represented, in any way imaginable, the citizens of democracies are redeemed. They are calmed and socialized by seeing and hearing their likeness in the tapestry of the ongoing pageant. This vision of democracy, as more theatrical than dramatic, has the virtue of privileging civility by reconstituting reflection and speculation as literal activities and rewriting ideological content into narrative fiction.

4 Backstory in Italy

The first time I was in Rome, [in 1506] when I was young, the pope was told about the
discovery of some very beautiful statues in a vineyard near S. Maria Maggiore. The pope
ordered one of his officers to run and tell [my father] Giuliano da Sangallo to go and see
them. He set off immediately. Since Michelangelo Buonarroti was always to be found at
our house (my father having assigned him the commission for the pope's tomb) my father
wanted him to come along too. I joined up with my father and off we went. I climbed down
to where the statues were, when immediately my father said, "That is the Laocoon, which
Pliny mentions." Then they dug the hole wider so that they could pull the statue out. As
soon as it was visible everyone started to draw, all the while discoursing on ancient things,
chatting as well about the things in Florence.

Francesco da Sangallo, in a letter, 1566

During the fifteenth and sixteenth centuries in Italy, a loose confederation of artisans and church decorators created a body of artistic work whose authority utterly eclipsed the agendas it had been designed to promote. In recognition of this achievement,

the elite category of cultural and commercial value—previously restricted to works of classical antiquity—was tacitly expanded to include the work of contemporary masters. In 1605 this expanded category was confirmed in writing by the city of Florence when it passed an edict that forbade the sale and export of any work on any subject by eighteen artists, including Leonardo, Michelangelo, Raphael, Del Sarto, Correggio, Parmagianino, and most of the rest of the Italian canon.

The artists whose work is singled out in the Florentine edict had all executed permanent public works for churches and civic buildings throughout Italy. The objects at issue in the edict, however, were those visually dazzling, readily portable paintings on canvas and panel whose most amazing attribute in their own time was their public vogue—their celebrity in a fame-crazy culture—their burgeoning marketability in a renascent commercial society. It is true, of course, that this work was idealistically inspired by the corporeal authority of classical sculpture, casually informed by the cosmopolitanism of Roman learning, and justified, as often as not, by the casuistry of Neoplatonist gurus. It is also undeniable that these paintings and the artists who made them remained fully complicit in the incarnate mysteries of primitive Catholicism and indebted to its ideologies.

The conflicted debt these paintings owe to Renaissance fashion and commerce, to primitive Catholicism and classical paganism remains unpaid to this day. It is still an active ingredient in most of our arguments about art and about all our experiences that are

confirmed in perception, under the rubrics of beauty, grace, and eloquence. The complexity of this inheritance is demonstrated succinctly by the agendas, controversies, and rationalizations that swirled around the greatest technological innovation in Renaissance art: the practice of oil glazing, which first proliferated in Northern Europe and quickly made its way south. Oil glazing involves the application of transparent layers of pigment suspended in oil, one over the other, to create the ravishing surfaces whose luminosity became the trademark of this painting. Since it mimics the layering of white people's skin, the technique itself probably derives from observation. The practical virtue of this layering is that it simultaneously evokes the seductive corporeality of flesh and the translucency of antique objects carved in marble.

The ostensible theological rationale for this invention was its ability to make the doctrine of the Incarnate Word palpable in portrayals of Christ, and particularly the Christ child. Even though oil glazing was never restricted to painting the body of Christ, oil-glazed surfaces do allow ambient light to pass through levels of transparent color and bounce back so the paint appears to hold the light and glow. The seductive simultaneity of light and gross matter was taken as a metaphor for Christ's simultaneous mortality and divinity as the word of God made living flesh. In its broad, everyday applications, this shadowless and, by inference, timeless, luminosity was also presumed to signify eternal grace—the visible investment of a mortal body with some aspect of immortal sanctity. This visible investment, however, is not properly a *meta-*

phor for timeless grace, since the presence of grace in Renaissance theology is presumed to be visible in fact. Eyewitness testimony affirming the visible aura of grace was always considered in the clerical adjudications that surrounded the bestowal of sainthood.

So, if grace can be seen in fact, then what is the status of objects whose physical luminosity *replicates* the state of grace? A person invested with grace is visibly a saint. An object invested with grace is a sacred icon. A mimetic picture, however, is a representation that stands in for the absence of its physical subject. What, then, is a mimetic image of Christ that, thanks to oil glazing, seems an uncanny *incarnation* of Christ? Is it a picture, an icon, a craven idol, or something else? If it is only a representation of the historical Jesus, it stands in for Christ and signifies his *absence*. Yet Christ, conceived in grace, is *never* absent, and any presumption that a man-made picture might embody Christ plays fast and loose with the Second Commandment. So the Roman church proclaimed such works to be images of the *once and future* Christ, whose life on earth was historical and will be again, whose spiritual presence is eternal and signified by incarnate luminosity.

The church's idea that works of art might exist in a simultaneous condition of absence and presence, as both representations and incarnations, persists throughout the history of Western art, reaching its modernist apotheosis in Impressionism and Minimalism. The critical issue in Catholic Italy, however, was not explained by the official explanation. What is the *source* of this once and future visible aura? Christ was conceived in a state of

grace. Everyone and everything else must be invested with grace from without. The Catholic church claimed the right to invest human beings with grace. Protestants and dissenting Catholics believed that human beings could be invested with grace by God directly, without clerical intercession—that believers might become, in the Congregationalist idiom, "visible saints." Tangible relics of human beings who have been invested with grace by the Catholic church might, according to that church, invest the icons that contain them with grace. Dissenters held objects and images purportedly invested with such sanctity to be nothing more than false idols and pagan simulacra of Christianity.

To many moderns these issues seem trivial. They are not. Wars have been fought over them, and one cannot help but suspect that these issues of incarnation and idolatry, of grace and its investiture, were greatly exacerbated by the challenge of Renaissance painting. This extravagant painting (which must have been all the more ravishing in the image-poor culture of its time) would ultimately break the supply-side stranglehold over its proper uses. The theological hairsplitting that surrounded paintings' ability to persuade the eye while proving nothing by the Word or by reason, remains ubiquitous. Even today, the phrases "craven idolatry" and "commodity fetishism" may be substituted for one another with no loss of sense. Artists and art-lovers alike still implore us to drive the moneychangers from the temple of art—even though there is no such temple, nor has there ever been.

The idea of grace as sanctity-visibly-confirmed, however, echoes

Quintillian's insistence that, unlike philosophy, the embodied eloquence of the orator can never be counterfeited; this translates easily into Ruskin's "argument of the eye"—the idea that beauty need only be seen to be believed. An object in a state of grace, an oration that embodies true eloquence, and a work of art in an autonomous state of quality, goodness, or beauty are almost identically characterized: the artwork, the oration, and the icon are presumed to incarnate a condition of extrahistorical once-and-future authority. The question remains, however, for saints and paintings alike: *What is the source of this invested value?* Does the saint's state of grace derive from God directly or from the church? Does the painting's authority derive from God, who authorized the institution that sponsored its creation? From the artist who created it? From God, who inspired the artist? From the iconographer who determined its content? From the devotional efficacy of the stories, grounded in The Word, that it tells? Or, perhaps, a painting derives its authority from a constituency of beholders who have experienced its power, agreed upon its loveliness, and publicly confirmed its authority in word and deed? In the history of commentary on art, all of these sources of authority have been passionately defended except the last, which I would like to passionately defend—the idea that the power of art may come from its beholders.

We know that enthusiastic secular constituencies created the public vogue of Renaissance painting. We know that this public vogue created an extra-institutional beaux-arts tradition that lasted four hundred years. We still hesitate to acknowledge its primacy

because a crowd of enthusiasts talking around and about a work of art evokes the noisy chaos of the souk. It calls to mind the louche abandon of feckless Israelites dancing around the golden calf. And it should. Francesco da Sangallo's description of the chattering crowd gathered around the pit from which the Laocoon has just been exhumed should tell us: *Fine Art Begins Here!*—in the heady blend of pagan reverence, commercial interest, artistic passion, intellectual curiosity, and worldly ambition.

Everyone present at the excavation is drawing, talking, comparing, and appraising. The Laocoon, rising from the earth, is at once a golden calf, a prized commodity, an artistic challenge, and a confirmation of ancestral wisdom. Giuliano da Sangallo, who recognizes the statue from an antique description (not Pliny's, though), is an architect by profession. Michelangelo Buonarroti is both an artist and an architect. On this particular occasion they are both commercial agents of the pope, and it's hard to see how this circumstance might diminish our assessment of either man. Contributing to the rescue and preservation of the Laocoon is hardly an offense against culture. Ignoring the impact of commerce, competition, consumption, avarice, and social aspiration on the history of art does qualify, however. It simplifies and mystifies art's primal occasions and leads inevitably to writing in which the terms "magic" and "inspiration" are bandied about.

I am more comfortable tracing the origins of Renaissance image-making to the late Middle Ages, when the Catholic church began outsourcing its decoration piecemeal. Over the next few

centuries, the sacred orders that had served as in-house marketing departments were gradually reassigned. By the mid-fifteenth century, the visual marketing of Western Catholicism could be said to reside firmly in the hands of private contractors overseen by commissioning bishops and scholarly iconographers. Ultimately, the church in Rome, as an image-provider, would function as a public-private conglomerate surrounded by a satellite ring of competing subcontractors. (Consider the competition in 1401 between Brunelleschi and Ghiberti for the contract to portray the sacrifice of Issac on the doors of the baptistery of the Florence cathedral—the outcome of which launched Ghiberti on a career of bronze doors and drove Bruneleschi into architecture, much to his chagrin and our own joy.)

Over the years, this outsourcing project had a threefold effect on art practice. First, unlike the artisans within sacred orders, these new subcontracting artists, artisans, and ateliers vied for competitive advantage. They developed trademark styles and guarded their techniques and technologies as proprietary knowledge. (This, by the way, is the best argument I know for David Hockney's thesis about the covert use of sophisticated mirror technology by artists in this period.) These entrepreneurs invested their production with idiosyncratic mannerisms on the principle that getting your style on the ceiling improved your chances of getting it in the nave. Second, the daily scrum of stealing, borrowing, refining, and inventing eroded the integrity of regional artistic idioms. Expatriate artists and artisans, brought to Rome by

provincial popes to celebrate their papacies in local styles, stayed in Rome, absorbed local influences, and continued to compete in an increasingly cosmopolitan stylistic environment.

Finally, and most importantly, the church's public administration of private art practice created a nascent art world populated by connoisseur churchmen and scholarly iconographers well versed in artistic practice and conversant with its classical and contemporary texts. Since these clerics commissioned and oversaw the production of works of art whose ideological content was identical by fiat, they evaluated the work of artists via the *paragone,* compared works according to their formal and rhetorical acuity. These gentlemen of the church were not, after all, going to artists to "get the word." They were going to artists to get the Word made flesh. Without their imposition of ideological consistency, the Renaissance orgy of formal diversification, visual refinement, and technical invention would, almost certainly, have been a lot less exuberant.

The tripartite artistic agenda, to distinguish one's product, while changing it with the fashion, while holding its content steady, created enormous tectonic pressures on the practice of art in the sixteenth and seventeenth centuries. The content and intention of Renaissance painting was, for all intents and purposes, static, a given. Style was indispensable and style-change was a commercial necessity mandated by the fashions of the marketplace. The practice of painting responded to this pressure to be at once singular, old, and new by becoming more refined, spreading like a river delta,

dividing and redividing in graded distinctions of increasing deli-
cacy. Because of this, the steep curve of escalating sophistication in
late-sixteenth-century Italian painting had its darker consequences.
Throughout this era, under the pressure of competition and in re-
sponse to the formidable challenge of Reformation, Italian paint-
ing assumed new grandeur at the expense of what, in retrospect,
seemed like its innocence. The vivid, corporeal verisimilitude of
these paintings, striving to beguile an unlettered audience, striving
to change without changing, enlisted ravishing sensuality in aid
of sacred circumstances and created the fulcrum upon which all
future critiques of "truth besmirched by beauty" would turn.

5 The Aesthetic and the Anesthetic

It is curious that princely galleries were so highly admired during the sixteenth, sev-
enteenth and eighteenth centuries, a period during which the hierarchal classification
of the arts was taken for granted and the orthodoxy of religious imagery was a matter
of real consequence. No one seems to have complained that, by treating portraits on the
same level as history paintings and by hanging altarpieces . . . next to scenes of the most
enticing eroticism, collectors were defying the considered teaching of churchmen and
philosophers in order to create a category of art for which only aesthetic quality needed
to be taken into account.

Francis Haskell, *The Invisible Museum*

The application of the *paragone* compares artworks like to like and
turns them inside out, so that their narrative content comments

on their attributes as objects (as the icing on Wayne Thiebaud's layer cakes comments on his appetizing *peinture*, as Tom Wesselmann's stylized nudes comment on the erotics of painting itself, as Donald Judd's rigorous permutations comment on the impersonality of his work's glamour). I call this the Aesthetic Maneuver. Such a maneuver may be said to have taken place when a seventeenth-century Italian standing before Caravaggio's *Entombment* in the Cheisa Nova is transformed from a simple Christian into a connoisseur of Christian art. In that instant, the Roman church has lost a communicant and one of its most powerful instrumentalities. Today, Caravaggio's painting remains in the church's custody in the Vatican Pinacoteca, but it is no less free. Crowds shuffle past. They shudder in the grave that Caravaggio has dug for them, only half aware of who is being entombed and why, yet their awe is undiminished. They pass on, daunted but enlivened by the dour occasion, because the *Entombment* has been granted its secular immortality.

In this exact sense, choosing beauty over content (or choosing beauty *as* content) is always an act of sedition. If we accept the cant of official culture, we must believe that the beauty we steal from any man-made thing is stolen from its more virtuous and metaphysical backstory, wherein "real" beauty is said to reside. Official culture must regard our habit of casually ignoring these off-site narratives as, at least, a misdemeanor, like ignoring a stop sign, or, on more august occasions, as a treasonous felony. Andy Warhol would invent a strategy for feigning compliance by

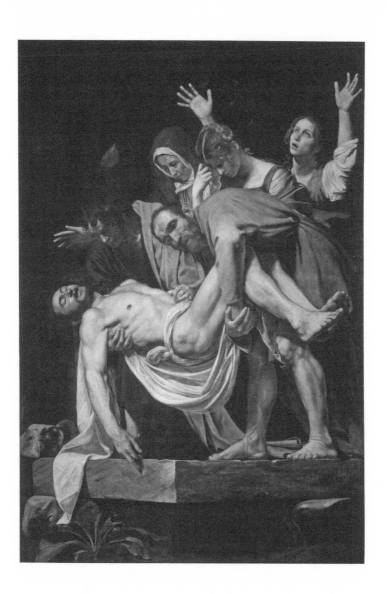

"getting it exactly wrong," by creating the effects of Abstract Expressionist paintings while stripping away the expressionist cant that informs their piss-elegant aura. Susan Sontag insists in her diatribe "against interpretation" that the problem is not interpretation (we all interpret—can't help but do so) but in the tyranny of interpretation.

So all our great good fortune begins with a crime. The founders of the beaux-arts tradition steal Renaissance painting from the church by misinterpreting it—then hand it over to us for further misinterpretation. As Francis Haskell observes, the princely collectors of the seventeenth century invent "a category of art for which only aesthetic quality need be taken into account." This category, of course, is not really a category of art but a categorical way of *looking at art* that, among princes and cognoscenti, privileges the comparative quality of the object's visual aplomb. Thus, the singular attribute of beaux-arts connoisseurship is Ruskin's "innocent eye," simple sight precedent to "insight." One need only appraise a painting of mallards in flight as a painting compared to other paintings—not as a representation of waterfowl to be tested against reality.

This is not rocket science. Ignorance is as good a reason to speculate as impudence or curiosity. Thousands of brilliant readings

have arisen out of ignorance—some of them mine, none of them Freud's. Subteen cults routinely claim anthems from the songbook of Oswald Osbourne as their own. They find magic meaning in them. Oswald expects and encourages this, and I rather suspect that Raphael and Caravaggio did too. Their paintings are rife with double-entendres and private jokes. Why else would Caravaggio paint the beautiful bum of a beautiful boy at the dead center of his *Flight into Egypt*, if not to have a little joke at the expense of solemnity?—just the kind of secret joke that gangs of teenagers, French film buffs, aging Trekies, and the occasional Charles Manson routinely discover in their own cultural icons (*pace* the amazing revelation that "Paul is dead").

These cults of marginal enthusiasm, as nerdy as they are, do not differ much from the aesthetic cults of the art world. Aggregations of adepts espouse a specialized way of looking at things. You either get it or you don't. If you get it, you join a semisecret order—a festival of insider trading in which a revolutionary Aesthetic Maneuver, successfully executed, may redistribute the wealth of nations and change the world. The revolutionary occasion may be triviality itself, a flicker of resemblance. Dante Rosetti notices that the young women in his crowd (Elizabeth Siddal, Jane Morris, Effie Gray, Fanny Cornforth, and Anne Miller) resemble the young women painted by the Florentine, Alessandro Botticelli. He remarks on this to Edward Burne-Jones and John Everett Millais. They agree. All three set to work on neo-Botticelli portraits. By this route, the genetics of Victorian womanhood, enhanced by

its regimen of diet and exercise, allows the members of the Pre-Raphaelite Brotherhood to enhance their careers by resurrecting a well-known but presently unfashionable artist. In the process, they invent the bourgeois art market in Britain.

So Botticelli returns to fasion from his long exile. Orange hair is back. Ladies fashions turn Italian. Collectors get to collecting. Scholars get to scribbling. All this because Victorian maidens look like Florentine ice princesses. A century later, another fugitive resemblance: postwar American beauties start to resemble Victorian maidens. Roy Lichtenstein and Andy Warhol get it, and the Botticelli thing too (re: Edie Sedgwick!). Roy and Andy resurrect Pre-Raphaelite lovelies from their own exile in the funny papers, and reinstate them as beaux-arts heroines. (*Oh, Brad!*) Andy even buys a suite of red chalk drawings by Dante Rosetti of Fanny Cornforth in all her blondness—Marilyns avant le lettre—and hangs a row of them in the hunter green entry hall of his brownstone. Then braids are back. Hippie chicks embrace the Primavera's aura of frantic hedonism. Emilio Pucci invents colorful, diaphanous neo-Florentine frocks. Roy, Andy, and their friends invent the bourgeois art market in the United States.

Thus, Botticelli is resurrected by theft. Through a flurry of resemblances and cross-references, the Renaissance referents that Botticelli's paintings evoked are replaced with updated running gear, once in the 1860s and again in the 1960s. For a dead painter, this is a good sign. Objects once stolen from their official source have a propensity to be stolen again. The abil-

ity of oft-stolen images to acquire new meanings over time is enhanced. The odds of their survival under fluid cultural circumstances are greatly improved. The likelihood of such images *sustaining* cultural meanings long enough to communicate official propaganda is virtually nil.

Why? Because objects in the beaux-arts tradition survive unblemished by time. They stand still. History flows through them. The old goes in and the new comes out. Stable, historical objects are reaccredited. Their aura of flexible signification liberates them from their original authorization. Dynasties die out. Nations crumble. Theories dissolve. Institutions wither. Objects survive because we like them and because we somehow recognize our likeness in them. For five hundred years, adepts of the beaux-arts tradition rescue beautiful objects ready for the dustbin—long past their "use by" date—on the premise that a beautiful man-made object, regardless of its cause or content, is preferable to one that is not so *beaux*. Even more amazingly, man-made objects, once found beautiful and no longer considered to be, are rescued, as well, on the grounds that they might become beautiful again.

This is why Rubens and his friends bought Caravaggio's *Madonna of the Rosary* from a storage shed in Naples and gave it to a church in Antwerp. This is why Rubens persuaded the Duke of Mantua to buy Caravaggio's *Death of the Virgin* after Sta. Maria Della Schola had rejected it as "inappropriate." This is why Guidobaldo Rovere's raffish nude, painted by Titian, hangs in the

Uffizi in classical drag as the *Venus d'Urbino*. During its residency in the duke's bedchamber, the work was simply catalogued as "a painting of a naked woman by Titian." Titian's pinup, however, was quickly recognized as quintessentially Italian—as opposed to quintessentially Greek or Roman or Byzantine—in a moment of intense Italian cultural self-consciousness. So the naked woman was "cool" (or whatever the sixteenth-century slang might have been for objects that are unassailably *au courant* despite their inappropriateness).

In this ragtag manner, the beaux-arts sensibility saves what can be saved, piece by piece, through hoarding, thrift shopping and dumpster diving. Everything stolen is in some sense memorable, or else it is forgotten. Each object resides somewhere in the vast imaginary warehouse of human recollection and resemblance, each with a provenance of approval, each responsive to the beaux-arts way of looking at things and open to interpretive resuscitation. Beauty is the occasion. Content is a matter of taste. Style is the indicator of temporal fashion. At one time or another the works of Botticelli, Guido Reni, François Boucher, Henry Moore, Morris Louis, Jules Olitski, Ronnie Bladen, and David Salle have been banished by fashion from serious interest—but they were never ejected from the warehouse of recollection. Fashion is dialectical. The likelihood of these objects returning to public vogue is actually enhanced by their being quintessentially unfashionable in the moment and waiting just offstage.

From the sixteenth through the eighteenth century, the sites

of official art patronage dispersed across Europe. Competitive nation-states and their aristocracies joined the church as purveyors of artistic propaganda. The Aesthetic Maneuver persisted, with its permission to personalize and commercialize objects of official propaganda. The gradual erosion of religious and aristocratic authority during this period seemed to foreshadow the ultimate triumph of a purely "aesthetic" art. Panic at this prospect, however, created the conceptualizing *Anesthetic* Maneuver to reinvest works of art with elements of public virtue, social consequence, and philosophical interest.

As a result, there are today hundreds of "better" reasons for looking at works of art than enjoying the way they look. Many of us indulge our appetites by embracing any semi-legitimate reason that falls to hand, but, the urge to tease out "serious" reasons for looking at art is far from reactionary folly. Primary among twentieth-century reasons is our awareness that beauty, in the hands of authority, unmitigated by democracy, ranks high on the Richter scale of social consequences. Our awareness of beauty's power, unfortunately, has persuaded us against all reason that the public virtue of art exists in spite of, apart from, and in opposition to its physical appeal. Fine, except for the fact that *Beauty is precedent*. Beautiful works survive sans virtue. Virtuous works sans beauty do not. In a democratic society, we express our discomfort with Beauty's off-site rationale by dispensing with it. But we keep the beauty.

6 The Waltz of the Anesthesiologists

Some writers have so confounded society with government, as to leave little or no distinc-

tion between them; whereas they are not only different, but have different origins. Society

is produced by our wants, and government by our wickedness; the former promotes our

happiness *positively* by uniting our affections, the latter negatively by restraining our

vices. The one encourages intercourse, the other creates distinctions. The first is a patron,

the last a punisher. Society in every state is a blessing, but government even in it best

state is but a necessary evil.

Thomas Paine, *Common Sense*

Before the French Revolution, the imprimatur of church, state, and aristocracy might be said to have anesthetized works of art while validating them. We were free at the time to ignore the work's official content but not yet free to replace that meaning. In the late eighteenth century, the anesthetic wore off. The ideological neutrality of art burst asunder. The pastime of connoisseurs, who ignored the king's meanings, became the practice of the masses. What the Aesthetic Maneuver had previously suppressed, it now wiped clean and thus made the future possible. Paintings like David's *The Oath of the Horatii* and *Death of Marat* were taken to represent opposing political interpretations of genuine gravitas, whose historical meanings were confirmed on the barricades and on the guillotine.

The Anesthetic Maneuver, then, should be seen as a complementary consequence of the Aesthetic Maneuver, not as its oppo-

nent. In the early nineteenth century, everything was up for re-interpretation and our flailing efforts to deal with the new world of multivalent objects engendered a quantum escalation of art's perceived cultural importance. Romantic writing and the dawn of industrialism transformed art and craft into the very emblem of human aspiration, historical achievement, and cultural identity. Soon thereafter, new, purportedly scientific teleologies arose to fill the vacuum left by the collapse of traditional interpretation, but art still bore its newly invested relevance.

As a consequence, the theories that flowed from the pens of Herder and Hegel, Darwin, Marx and Freud, all of which proposed brands of historical formalism, had uses for the art of the past. Works of art that would have been banished by the Reformation simply reopened under new management. Art that once argued for the primacy of church, state, and patrimony now argued for "natural selection," "the class struggle," and the validity of "oedipal rage." In what is now Germany, the art and folk art of the past was upgraded, "correctly reinterpreted," and exhibited in *Kunsthalles* to validate separatist myths of cultural identity, regional autonomy, and tribal tradition.

The bête noire of all these manly narratives was the gaggle of aristos, dilettantes, and poetasters who constituted Anglo-French beaux-arts society. These cosmopolitan dandies—dismissed by their German counterparts as "preening dancing masters"—were, indeed, long on whimsy and short on attention span. In the mid-nineteenth century, however, their society brought forth an ex-

clusively beaux-arts *practitioner* in the person of Edouard Manet. Manet and his followers (along with their Pre-Raphaelite cousins in Britain) firmly established a bourgeois art market free of institutional oversight. Almost simultaneously, a newly minted cadre of German academicians, called "art historians," sought to bring the flurry of free interpretation that had been occasioned by the French Revolution back to order by establishing a new regime of *correct interpretation*. Henceforth, in Europe and America, an academic establishment strove to muffle art's efficacy by specifying its original cultural intentions. Alongside it, an unofficial class of collectors, dealers, critics, and artists sought to exacerbate its local effects.

Beyond the realm of academia, casual, freehand reinterpretation continued to flourish throughout this period. Aesthetes and anesthetists addressed the same field of objects. It was presumed that works of private delectation might acquire sufficient credibility to be considered as icons of public virtue—through the investment of interest by private constituencies. Aesthetic and anesthetic virtues might coexist in any object that could sustain both regimes of interpretation. This premise guided the art world in the United States and Western Europe for the first two-thirds of the twentieth century. It raised the bar for artistic acclaim by requiring the presence of both artistic and intellectual virtues. It required memorable works of art to be *worthy* of remembrance, with the caveat that *only* memorable works were worthy at all.

The most beguiling attribute of this aesthetic/anesthetic dis-

course of objects is that it conforms to Foucault's conditions of language by insisting on the precedence, if not the primacy, of the aesthetic. To redact Foucault, this society accepted, almost by definition, that beaux-arts discourse rested on a foundation of "formal values"—of resemblances, repetitions, and natural crisscrossings that had been excluded from knowledge since the seventeenth century—that this foundation of lateral references existed below the level of identities and differences—that it was precedent to that which can be analyzed, reduced to order, and known—and that, without this foundation, nothing could be known or even remembered.

So things were remembered. As in the sixteenth century, a hard market in objects provided the spine of a broader and more complex civil discourse about artworks that one needn't own to critique and evaluate. One need only *remember* them, and the task of being remembered fell to the works themselves, since they were sustained in public vogue only by this ongoing, external investment of value. In this period, the accrediting function once exercised by the worldly bishops fell to freelance arbiters of taste who bet money, essays, books, bequests, exhibitions, chatter, hints, nods, and knowing smiles on the public consequence of the art they favored. The arbiters with the best track records became aristocrats in a tiny world of volunteers. Those who were mostly right and never wrong wrote history.

By 1974, this transatlantic discourse was all but defunct. By 1605, its Italian counterpart was also defunct. Both dissolved for

the same reasons. The transatlantic art world became a global art world. The Italian art world became a European art world. The field of shared assumptions, visual experience, and philosophical education shattered, never to be reconstituted. The ancient agora within which citizens compared things like to like began to resemble an exclusive club. Finally the critical languages that characterized Italian and transatlantic art in their heyday proved to be woefully inadequate. Sixteenth-century critique was revealed to be intrinsically medieval. Twentieth-century criticism proved to be woefully indebted to nineteenth-century modernism, to the historicizing of Herder and Hegel, Marx and Freud.

My suggestion here is that, if we presume twentieth-century critics to have been as wrongheaded and nondescriptive as their sixteenth-century counterparts, the sobriquet "high modernism," as applied to the brand of art that began with *Les demoiselles d'Avignon*, seems nothing but a dated excuse to validate dead language—especially since the cream of high modernist art conforms to the conditions of postmodernity described by midcentury continental theorists. Roland Barthes, after all, killed the author on behalf of all objects and texts, so that we might have Picassos without Picasso. And without Picasso, what is modern about a Picasso that is not postmodern? Likewise with Stein, Joyce, Stravinsky, Piscator, Nijinsky, Man Ray, Beckett, Picabia, and Duchamp. Viewed as authorless, all of these artists' work has the crazy tang of exploding history. All of it posits a substrata of "resemblance precedent to differ-

ence." None posits meaning outside the text. None manifests the least affection or affinity for the industrial modernism of the nineteenth century.

More to the point, if we think of high modernist art as postmodern art, the art that arose in its wake must bear that hilarious, oxymoronic title of "sincere postmodern art"—although it doesn't really deserve a name at all. To enforce this point, here's a little historical rhyme: The fate that befell sixteenth-century Italian painting also befalls transatlantic art in the first two-thirds of the twentieth century. In two words: The Academy.

Under its weight, around 1974, the beaux-arts tradition collapses. Everybody forgets everything. The fluid commingling of the aesthetic and the anesthetic is sundered at the level of practice by an academic reformation. The academy of anesthesiologists, whose original agenda was only to make art more culturally meaningful, becomes increasingly concerned with making art less aesthetic—with shredding the beaux-arts filigree of resemblances, similitudes, harmonies, and resonances—with forgetting the way an Edo screen illuminates a drawing by Degas. It seeks to reinstall the autocracy of origin, difference, and identity. Under this flag, anesthesiologists backed by official authority rise up against self-employed aesthetes, and guess who wins?

Almost immediately, public support for art in the form of tax incentives for private benefactors is replaced by public support for art governance in the form of direct grants, and, as Thomas Paine would have predicted, the newly empowered art government—

free at last from the cordiality of society and the marketplace—addresses itself to our wickedness and finds it in full abundance in the art of the present, in the art of the past, in artists, genres, ambitions, and every variety of content and rendering. A regime of correct speech is instituted to "civilize" Americans by limiting their moral and aesthetic choices under the oversight of a European-style bureaucracy of guardian civil servants.

On the morning after the coup, "noncommercial art" comes into being. This is not simply "art that doesn't sell" (of which there has always been a surfeit); it is art that doesn't sell but nonetheless pays very well because institutions will patronize art that suppresses the attributes that guarantee art's survival in the public memory and imagination. So noncommercial art is ephemeral, site specific, and heavy on *objets trouvés*. Lacking stylistic precedent and the incentive to change, it doesn't. Its technologies evolve; that's it. Bereft of pattern or idiosyncrasy it is quickly forgotten, gone before we notice, but no worry. Since it cannot be misinterpreted, an official interpreter can just tell you what the artist means. Thus, "misinterpreting the artist's intentions" quickly replaces "ornament" as art's capital crime.

Works of art under this regime represent the exclusive interests of their preexisting constituencies. After four centuries of theft, inside jokes, cross-pollination, and misappropriation, all stolen or borrowed art is returned to the churches, states, cultures, classes, races, places, genders, philosophies, and traditions from which it has been snitched. The past is sent home. Efforts to maintain the

art of the past in contemporary vogue are written out of the budget. The stylistic influence of art created before 1970 is obliterated. The task of sorting out who can claim the benefit of what object becomes a major industry. Many artists of consequence, like Degas and Picasso, are found guilty of profiting from the theft of proprietary iconography.

The beaux-arts agora that provided a site for arguing about our likes and likenesses is relocated deep in the wilderness of popular culture. The beaux-arts historical project of saving everything we ever loved just stops. We lose the object, our sophistication, and the pleasure we once took in outfitting official virtue in the clown suit of folly—the very emblem of civilized sedition. Word walls arise to water-board works of art with verbiage and stunt their life expectancies. The amateurs who built those halls of culture, who filled them with treasures, are relegated to the dark past, their passions relinquished into the custody of philistine colonizers for use in outreach projects to the skateboard community.

Then, around 1993, the anesthesiologists' discourse just goes poof. It evanesces without leaving a trace in fact or memory, just assorted shreds of jargon and faded photo-documents. Everybody is going to the art fair! And we are right back where we started, in Florence talking prices on the balcony in the sunshine. We perform upon a larger stage, quaff better wine with more culturally diverse aristos, but we have managed somehow to re-create that ruthless sixteenth-century carnival of fame, folly, avarice, waste, and swagger without the Leonardos, or the Raphaels, or even the

frivolously talented Parmagianinos, without the kvetching critics who might remind us that, after all that's happened in the last sixty years, the schism of virtue and beauty remains intact.

7 The Pagan Embrace

The branch from which the blossom hangs is neither long nor short.

Krishnamurti

Here beginneth the ending, with a bald assertion that pleasant surprises do, in fact, exist. Their social, psychological, and somatic dimensions are radically contingent and infinitely complex, but beyond the opacity of the occasion there is no question about whether they happen. They do, and they provide the foundation for a vernacular discourse of beauty—a perfectly explicable mode of adjudication requiring nothing more of its practitioners than a reversal of Western civilization's semiotic priorities by application of the *paragone*—by habitually looking like to like. As Oscar Wilde remarked, "a gentleman always judges by appearances." We begin our education in doing this with a base premise of American semiotics: All simple signs have two primary domains of reference. (1) All signs that we call signs have *designative* meanings. They refer to things that are *unlike* themselves—as words infer their referents and pictures what they represent. (2) All signs that we call signs are also things in this world. They have *embodied* meanings. They

reference things in this world that are *like* them—as a word, a color, or a musical note is known with reference to other words, colors, or musical notes.

No one questions the existence of these two domains. Nor has anyone proposed a way of sorting our their tangled skeins of reference. The quarrel is about the relative priority of embodied and designative meanings—about what we know through which agency. Do we learn about the king (compared to other kings) through the agency of his portrait, or do we learn about the painting (compared to other paintings) through the agency of the king's portrayal? Do we learn about the table (compared to other tables) through Picasso's portrayal of it, or do we learn about Picasso's painting (compared to other paintings) through the agency of the table he portrays?

The king's portrait is *intended* to celebrate the king, of course, and Picasso's table is *intended* to celebrate his painterly cubism. As free citizens, however, we are unencumbered by authorial intention. We choose between two ways of reading that require two ways of looking at things. In practice, there is no absolute distinction. We always choose a reading somewhere between these two extremes. A reading weighted toward designative meaning prioritizes the absent king and the imaginary table. A reading weighted toward embodied meaning prioritizes the two paintings. Either is possible, but which is preferable and to whom?

Administrative cultures necessarily prioritize designative meanings. They are preoccupied with delivering the message,

keeping the record, teaching the lesson, and assuring our compliance. Their administrative job requires that they be relatively certain that we (their administratees) accept what they say words mean and what colors stand for. If we stop at the octagonal red sign and stop at the red light as well, they smile. Their ability to control our behavior is confirmed. They are urgently concerned with teaching us because they are concerned with our safety, not our happiness, but the world gets in the way. Their authority depends absolutely on our reading the designated reference of official signage correctly. Sadly for them, our propensity for looking like to like gives the *embodied* meanings of their signage cognitive precedence over its message.

When Jacques Derrida asserts that there is no meaning outside the text, he is not arguing for the priority of pages with words on them, but for the primacy of embodied relationships generally. He is arguing that any field of designative reference we construct behind the patterned signs that compose a text (and the patterned signs that express their meanings, and the patterned signs that express *their* meaning, ad infinitum) is radically contingent and literally imaginary. Embodied relationships are physical and perceptible without designative reference. They signify the *possibility* of designative meaning. The actual designative meanings we assign are always up for grabs. A framed pattern of colors may be a picture but not necessarily. A bounded series of words may tell a story or make an argument, but it needn't. Embodied patterns invite us to seek out designative meanings, nothing more, and

however well we have been indoctrinated, the beauty and authority of the embodied pattern *itself* is determined by us, as we read or chose not to. If we are empowered to respond and pass judgment, we do.

If we tend to privilege beauty and dismiss the banal and the grotesque, the seriousness with which we take any designative message is contingent upon our taste—upon our aesthetic response to the pattern of embodied signs. So the physical existence, the primal intervention, of embodied signs poses a perpetual threat to bureaucratic authority. If we exclude the Orwellian option of simply deracinating our languages, there are three administrative ways of addressing the problems that arise when our taste mitigates our compliance. One may obliterate taste by disenfranchising the polity and denying them their rights of preference. In commercial societies this is suicide.

Failing that, one might promote a quasi-Protestant "cult of content" in which embodied and designative meanings are presumed to vary inversely. This popular academic option holds that bad writing infers good meaning, that ugly painting infers beautiful content, and that dissonant noise defines good music. The only defense of this cult is that, on rare occasions, the bad does become good, the ugly beautiful, and the dissonant harmonious. But this is almost never the case. In the fullness of time, 99 percent of the bad, ugly, stupid, obtuse, and banal remains so and sinks into oblivion. Even so, there is always enough of it around.

Finally, there is the option of teaching taste to bureaucrats—of

training power's minions in a felicitous mode of embodied expression and educating the polity to appreciate it. This creates "appropriate" expression, and it works for the Brits, although the whole history of art in the West stands as gorgeous, proliferating testimony to the fact that nothing taught and nothing learned—nothing merely appropriate—can override the revolutionary efficacy of the pleasant surprise. A five-hundred-year tradition of aesthetic discourse rests upon one principle: *In the moment of encounter, intricately constructed patterns of embodied reference always have the potential to completely reinvent themselves, to reinvent their own pasts and yield up the future in new, surprising, and totally unauthorized designative meanings.*

Any citizen conversant in the discourse of relative beauty, with its perpetual promise of radical destabilization, must then be predisposed to question established authority at every turn, because the experience of beauty itself invariably overrides it. Confronted with inept administrative expression, we decry its ugliness and ignore it. Confronted with appropriate administrative expression, we wring our hands at its banality and ignore it. On those few occasion when we encounter administrative expression that is beautiful and surprising (while standing before a Raphael, perhaps) we still ignore the off-site message and keep the beauty if we can. We appropriate Raphael's painting and invest it with new social meaning.

So here is the argument: Human beings in the course of their daily lives experience involuntary positive responses to configu-

rations of embodied signs in the world, whether these responses are socially permissible or not. When the responses are permissible, we call others' attention to their source in the hope of creating a constituency of agreement with our own evaluation. So, in societies where it exists, the cognitive priority of embodied signs makes beauty a powerful category of value. If beauty does exist as a category of value, the cognitive priority of embodied signs more or less guarantees that the pleasant surprises we experience in the presence of art will function as a hedge against habit and rhetoric—will routinely preempt the blandishments of vested interest, tribal authority, transcendental religion, metaphysical ethics, and abstract philosophy.

The utility of beauty as a legitimate recourse resides in its ability to locate us as physical creatures in a live, ethical relationship with other human beings in the physical world. Natural and man-made objects reside at the heart of this discourse. The intentions and values that inform these objects bear no relation to any meanings they might acquire. These physical things provide us with a correlative, an interstice or pause, if you will, upon which the past and future may pivot. The past may create an object and that object create the future if we read the physical world as ancient oracles read the entrails of goats and the flight of eagles—if we are sensitive to the past, alive to present, and alert to the possibilities of the future.

The condition of existence I am describing is nothing more or less than ethical, cosmopolitan paganism—the gorgeous inheri-

tance bestowed upon us by the pre-Christian societies of the Mediterranean whose idolatrous proclivities have never been obliterated or even subordinated in the Christian West. Nor are they likely to be. The vernacular of beauty is a part of that pagan inheritance. The whole rhetoric of commerce and practical science is a part of it too, as are the foundational premises of this republic, whose framers embraced Cicero's insistence that the virtue of any politics is confirmed in the body of the citizen—in the corporeal safety and happiness of that single and collective body.

Talking about beauty involves us in a physical world bereft of transcendental attributes. It's human attributes are as numerous and protean as the gods of Rome (and amazingly similar in their utility). They fall to hand as we need them—novelty, familiarity, antiquity, autonomy, rarity, sanctity, levity, solemnity, eccentricity, complicity, and utility. Their value in the moment determines the temple at which we offer up our sacrifice. There is never any doubt of our desire, if we feel ourselves free enough to buy into the embodied panoply of likeness and resemblance before our eyes—not to own it, but to join it in a pagan embrace that closes the space between ourselves and everything beyond ourselves. It's hard to hold the world, of course, as we hold values dear, as we hold certain truths to be self-evident, but beauty, value, and truth arise out of the intimacy of that embrace. Beauty is and always will be blue skies and open highway.

ACKNOWLEDGMENTS

The essays in this book recount five excursions through the same terrain They intersect here and there, and I can only apologize for the redundancy and hope that the experience of passing the same burning bush on five different journeys from five different directions might lend it a certain dimensionality. While rereading this manuscript, I have also discovered several intransigent habits of mind that are not specifically articulated in the essays. These should probably be acknowledged. First, I have habitually suppressed the traditional opposition of beauty to ugliness and of pleasure to pain to privilege all of these extraordinary conditions over their true contrary: the banality of neutral comfort. This is, more or less, the point. Second, in discussions of the art market, you will find me disinclined to equate "commerce," which is characteristic of all human cultures, with "capitalism," which has plagued but a few. This is a matter of fact.

In the matter of indebtedness, I would hope that these essays

might stand as a tiny monument to the memory of Andy War-
hol, Robert Mapplethorpe, Gilles Deleuze, Michel Foucault, and
Jacque Derrida. As a thank-you to my friend Edward Ruscha for
all the beauty and mystery—and to the writings of Leo Steinberg
for encouraging my propensity to step out on the ledge. To Ed-
mund Pillsbury and the staff of the Kimbell Art Museum, within
whose lovely spaces many of the speculation have their genesis,
my deepest thanks, for their unfailing hospitality and generosity.

I must acknowledge once again my eternal gratitude to Gary
Kornblau, editor deluxe of the first edition. Without him, I would
never have written these essays or thought to collect them. Finally,
let me extend my affection and gratitude to Susan Bielstein, editor
of this edition, for convincing me to rescue these essays from the
dustbin to which I had petulantly consigned them, and for all of
her counsel and support during the resuscitation the dragon.

A short version of "Enter the Dragon" was published as "The
Invisible Dragon" in *Parkett* no. 28 (Summer 1991), in Zurich.
"Nothing like the Son" had its genesis in a lecture entitled "On the
Beautiful, the Sublime & the *X Portfolio*," delivered on February
8, 1992, at the Dallas Museum of Art and again, in the summer
of that year, at Art Center College of Design in Pasadena. "Prom
Night in Flatland" began as an essay entitled "Community Prop-
erty and the Eye of the Beholder" in *Eau de Cologne* no. 3 (Win-
ter 1989), published in Cologne; it was reprinted in *Artspace* (July/
August 1990), in Albuquerque. The original version of "After the
Great Tsunami" was published as "A Cloud of Dragons" in *Art*

Issues no. 27 (March/April 1993), in Los Angeles. The original version of "American Beauty" was published as "Buying the World" in *Daedalus: Journal of the American Arts and Sciences* (Fall 2002), in Cambridge.

122

123

ACKNOWLEDGMENTS